DATE DUE

			PRINTED IN U.S.A.

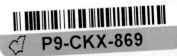

Starting with relief printmaking

Cyril Kent

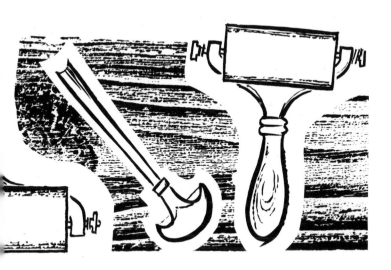

Studio Vista London
Watson-Guptill Publications New York

General Editors Brenda Herbert and Janey O'Riordan
© Cyril Kent 1970
Published in London by Studio Vista Limited
Blue Star House, Highgate Hill, London N19
and in New York by Watson-Guptill Publications
165 West 46th Street, New York 10036
Watson-Guptill ISBN 0-8230-6930-3
Library of Congress Catalog Card Number 70-119471
Set in 9 on 9½ pt Univers
Printed and bound in Great Britain by
Bookprint Limited, Crawley, Sussex
SBN 289.79651.2

Contents

Fig 1 *Three Cocks*, four-colour lino cut

Introduction

I am delighted to have an opportunity to enlarge on the subject of relief printmaking, which I dealt with briefly in a previous book in this series, *Simple Printmaking*.

One of the particular attractions of relief printmaking is the surprisingly small outlay needed to purchase the basic equipment, compared with most other printmaking methods. Working facilities too, although it is obviously an advantage to have a spare room or workplace where it is possible to leave everything at the end of the day, need not take up more than the corner of a living-room, provided the space is properly organized.

The printing can all be done by hand burnishing, except in those cases where a fairly large number of prints are required, or extra pressure is needed. Usually it is possible to find a small local printer who is prepared to print larger editions.

Once you have come under the spell of this very fascinating activity, you will find yourself looking at the visual world around you with renewed interest. Apart from the inexhaustible source of inspiration for printmaking that is to be found in nature and the everyday scene, 'found objects', which form the basis for collage prints, often used in conjunction with cut blocks, open up an entirely new and exciting field to explore. Even for those with little or no ability to express themselves with pencil or brush, it is possible, providing they have a feeling for the shape and texture of things, to create evocative and powerful images out of the discarded junk of society.

Although I have tried in this book to explain certain methods of procedure with regard to technique, I have also stressed the fact that there can be no fixed pattern of working – everyone will find his own way of resolving a problem, with application and experiment. Printmaking is an activity which calls for considerable resourcefulness, each fresh print undertaken will have its own inherent problems to which a solution will have to be found. It is this challenge which makes printmaking so rewarding an adventure.

For those readers who, like myself, are involved in teaching, I hope that the section I have included on children's prints may prove interesting, and help to develop a free, experimental approach to relief methods of printmaking within the classroom – exploring the potential of every available material. The possibilities which this basically simple technique offers for printmaking are inexhaustible, allowing far greater flexibility and spontaniety of approach than any other print technique.

Fig 2 Typical section through a relief block, showing weak shoulder due to incorrect angle of cutting tool

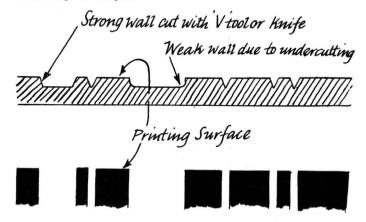

Strong wall cut with V tool or knife

Weak wall due to undercutting

Printing Surface

A relief print

A relief print can be simply described as an image, or impression, which has been transferred from an inked-up raised surface onto another material, for instance paper or fabric, etc.–in fact any surface capable of receiving it.

The relief may be of a purely organic kind, as is found in natural forms, like wood grain, bark, the vein structure of a leaf, etc. On the other hand it may be produced by cutting into the surface of a material, or indenting it by various means. Or the relief may be built up by fixing elements onto a base block, as in the case of a collage print.

There can be few readers who have not at some time taken a rubbing from the surface of an object–a coin, or perhaps a church brass or gravestone. Yet few would have associated the act with that of printmaking, although basically it is the same thing.

Until quite recent times, wood, and to a lesser extent metal, were the two materials principally used for relief cuts. However, with the introduction of synthetic materials of a compressed or laminated kind–linoleum, fibre boards, plastics etc.–the printmaker has found himself with a wide choice of materials for cutting and constructing relief blocks. Most of these new materials are in the form of sheeting and offer the printmaker greater opportunities for enlarging the scale and treatment of his design, because of their grainless nature and relative cheapness compared to wood.

Materials

Wood

There are many different kinds of wood which can be used for relief cutting. For convenience we can divide them into two groups: hard and soft woods.

For cutting, the soft woods, such as pine, maple, pear, cherry etc., are usually used. Cutting is done on the plank or side grain, see fig. 3. Woods of this kind may be bought type high (approximately $\frac{7}{8}$ in. thick), in blocks of various sizes, with a ready-prepared polished surface. However, as these are rather expensive, I would advise the beginner to try his hand first on something less precious. Any odd pieces of plankwood found around the garden or workshed, or purchased cheaply as off-cuts from your local timber merchant or lumberyard, will serve perfectly well for experimenting on with the various tools. In this way you will gain a true appreciation of the material, and of the character of cut that each of the various tools make.

Wood, being a living thing, has a growth pattern, which can be seen in the figuring of its surface. This figuring, which is the term normally used to describe the grain pattern on the plank face of the wood, is of particular interest to the printmaker, for it can serve not only as a means of contributing textural interest to a print, but may on occasions evoke the idea for the print itself. This I shall illustrate later.

Fig 3 Cutting surfaces of plankwood (a) and cross grain (b). The cross-grain cutting surface is used for engraving

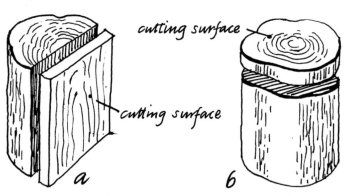

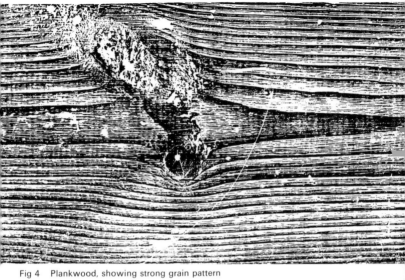

Fig 4 Plankwood, showing strong grain pattern

Fig 5 Plywood grain

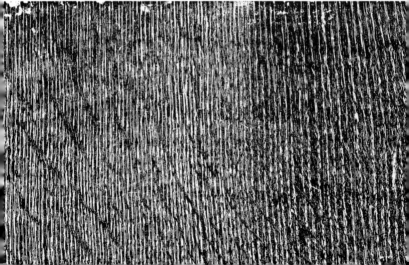

If required, the figuring or grain pattern can be brought out more clearly by using a wire brush. This lowers the softer fibre of the wood between the grain, to give greater relief.

Harder woods, produced by slow-growing trees such as box and holly, are used by the printmaker mainly for engraving upon, rather than for cutting with the knife and gouges. The reason is that these closer-grained woods, when cut on the cross grain and polished, present a perfect surface for the fine engraving achieved using the solid type of graver and tint tools, see fig. 17, page 24.

Fig 6 Print taken from inked-up surface of log

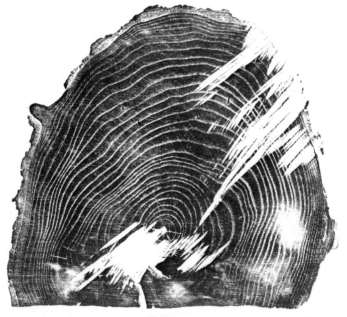

Plywood

This is an excellent material for relief printing; it is relatively easy to cut with both knife and gouges, and can be purchased in any size.

Plywoods less than $\frac{1}{4}$ in. thick are not likely to prove very satisfactory for cutting into, unless they are first fixed down onto a firm base to prevent curling, but plywoods of $\frac{1}{4}$ in. upwards are ideal.

The various timbers used for producing plywood, which is a laminated construction, offer a wide source of textural interest in their grain patterns.

Wood, both plywood and plankwood, which has been weathered by time and the elements, such as driftwood found on a beach or river bank, can prove most inspiring. Fig. 92 (page 95) is a print taken from a piece of driftwood ply which I picked up on the shore, the laminations having been opened up and splintered by the action of the sea.

Lino

Owing to its relatively soft and even density, lino has become one of the most widely-used materials for relief printing in recent years. Unlike wood it has no grain, and can therefore be cut with equal ease in any direction. In this respect it does not influence the cutter in the same way as wood does. The freedom and boldness of approach made possible by a material of this nature is especially attractive to the artist who favours the large-scale print in which bold, flat areas of colour are required.

Lino is manufactured in 6 ft widths and in thicknesses between roughly $\frac{1}{8}$ in. and $\frac{3}{8}$ in. Ordinary plain cork lino will be found the most satisfactory. Inlaid linos must be avoided. The thicker linos are more pleasing to work on, especially if the design is large. Thinner linos are quite serviceable however, providing they are not less than $\frac{1}{8}$ in. If large areas are to be removed from the thinner linos, it will be advisable to mount them on a suitable base board to prevent distortion, as for the thinner plywoods.

To cut lino to the size required, mark the shape out with a pencil on the face or on the canvas backing. If the corners require to be square, use a straight-edge and set square. This is particularly important where a number of blocks are used, for example in a colour print, which I shall be dealing with later (page 50). Having marked out the area, take a sharp knife and cut through to a depth of about $\frac{1}{16}$ in. If the lino is then bent, it will snap quite cleanly. All

13

that remains, if the cutting has been done on the front face, is to cut through the canvas backing.

The fact that lino is so readily cut to whatever shape is required, makes it extremely convenient to use in composite arrangements with other types of relief blocks, including collage materials (see page 63).

The cheapest way to buy lino is in the form of off-cuts, which can generally be obtained from any store that deals in floor coverings. Old lino, that has been well compressed through wear, providing it is of a suitable thickness and of the right type (cork not inlaid), will be extremely pleasant to work on. Odd surface scratches will rarely matter, and can often be exploited to good effect. In cold weather, lino is apt to become hard and brittle if kept in an unheated room, making cutting difficult. This is because the oil which it contains hardens. Slight warming before a heater will make it more pliable, and easier to cut.

Hardboard

This is a material widely used for domestic constructional purposes. Like many other similar types of compressed and laminated board, it has been found extremely useful in printmaking. Like lino it is a grainless material, but slightly denser and tougher in character. It is manufactured in various thicknesses between $\frac{3}{32}$ in. and 1 inch in sheets approximately 4 ft × 8 ft, and is appreciably cheaper than lino or wood. Off-cuts of various sizes are usually easy to obtain. The $\frac{3}{32}$-in. thickness is quite suitable for most purposes.

Normally the cutting is done on the smooth face of the board. The back has a texture (fig. 8) which, though mechanical in nature, can on occasions prove very effective, if used with discretion.

Due to the fibrous nature of hardboard, it has a tendency to tear when cut with the hollow gouges or V tool, although it will be found to cut quite cleanly with a sharp knife. I have found it helpful to cover the surface with a thin coating of ordinary flat house paint first, allowing it to dry thoroughly before cutting. This helps to prevent tearing. What must never be forgotten is that whatever the material, the cutting tools must always be kept properly sharpened.

Hardboard can be cut quite easily with a tenon or fret saw. Like lino, it may be inked-up separately after cutting, and printed together with other blocks to form a composite design.

Fig 7 Prints taken from canvased back surfaces and top of lino

Fig 8 Prints taken from textured back surface and top of hardboard

Softboard

This is a compressed fibre board, used mainly for insulation and display purposes, manufactured in a variety of thicknesses and surface textures. The thinner types, between $\frac{1}{4}$ in. and $\frac{3}{8}$ in., are generally denser in construction and will be found to cut quite cleanly with a sharp knife. Providing the treatment is bold and no attempt is made to use fine relief cutting, little difficulty will be experienced in printing from a material of this kind, either by hand burnishing or printing with a press.

Although the softer and thicker varieties of these compressed boards can be cut with the more conventional tools – knife, gouges etc. – and very vigorous effects achieved; because of their relative softness they cannot be expected to stand up as well in the printing process as tougher materials such as wood and lino. If printed in a press, care should be taken not to use excessive pressure so as to cause the breaking down of the relief.

Quite satisfactory results will be obtained by using a hard roller as a burnisher, rolling on the back of the printing paper placed over the inked block.

Softboard can be cut quite easily with a knife, making it possible to produce a multicolour design, if required, in a single printing, by inking-up a number of shaped blocks in various colours, positioning them on a base board, and printing them together. Used in this way greater flexibility is possible in their arrangement.

Blockboard

This is a fabricated board made up in the form of a sandwich, with a centre core of wood slats bonded edge to edge faced on both sides with a thin veneer.

It can be cut in much the same way as ply, but owing to the thinness of the veneer facing it is less suitable for deep cutting.

Blockboard is manufactured in different thicknesses, from $\frac{5}{8}$ in. to $1\frac{3}{4}$ in. and, like plywood and other laminated boards, is very rigid. It is less subject to warping than plankwood, which makes it an ideal material for packing up thin blocks, such as lino, hardboard or thin plywood, for printing with a press, see fig. 65, page 73. It will also be found very useful for constructing registration frames, bench hooks (see pages 22, 52) and similar accessories.

Chipboard

As the name implies, chipboard is an artificial material manufactured from wood chippings compressed and bonded with synthetic resins.

Its granular surface, when inked-up and printed, produces an exciting texture (see fig. 9), offering interesting possibilities when used in conjunction with solid areas of black or colour. Owing to the way it is constructed, chipboard is not suited to fine, controlled cutting, but lends itself well to simple strong cutting with knife and gouges, see fig. 26, page 33.

Fig 9 Prints taken from compressed boards. Left, softboard; right, chipboard

Tools

Knife

Traditionally the tool most widely used for relief cutting, especially for wood, has been the knife. Various types can be bought, differing slightly in pattern, such as those shown in fig. 11; but a stout pocket knife suitably sharpened and bound round with string to prevent the blade from closing, or a surgeon's scalpel, will serve admirably.

In the case of those illustrated in fig. 11, A and B are types most commonly used by western artists and C, which is the Japanese knife, by oriental artists.

The Japanese knife has a blade which can be adjusted in length, unlike the western one which has a fixed blade; this can be useful, especially after a blade has been reground.

To produce a line that will print white on a black or coloured ground, two incisions have to be made in the material, as shown in fig. 12. Although the V tools and gouges which I shall be describing next are capable of achieving a similar result in a single stroke, no tool can truly compare with the knife for versatility or boldness of effect.

Fig 10 Cutting with the knife. Unlike the Japanese method of cutting, the English knife is designed to be drawn towards the cutter

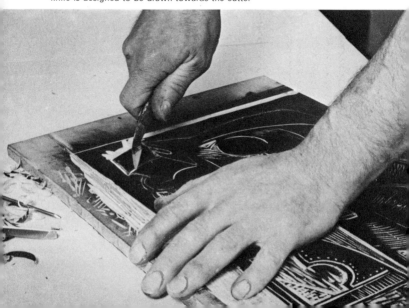

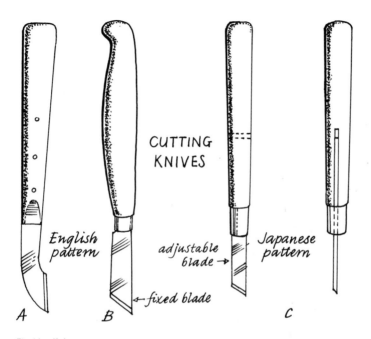

CUTTING
KNIVES

English pattern

adjustable blade →

← *fixed blade*

Japanese pattern

A B C

Fig 11 Knives

Fig 12 Knife inserted into block, showing cutting angle

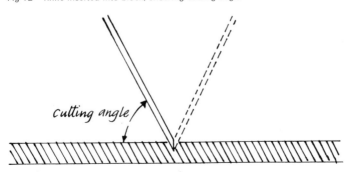

cutting angle

The V tool

This tool, which can be bought in various sizes, may be used as an alternative to the knife for cutting round the different shapes, especially when using softer grainless materials, such as lino, hardboard etc. As a tool for creating different sorts of textural interest in a print, it is also quite indispensable, see fig. 20, page 27. A little practice with the various sizes of V tool, altering the angle of the blade and length of cut, will quickly prove this.

The reason why the V tool is usually used for the first cut around the contours of those forms which require to be left in relief, has to do with its shape. If you look once again at fig. 2, page 8, you will see that a much stronger wall is left with the V-tool cut than with that of the gouge, which is mainly used for clearing the background areas away and for producing textures.

Both V tools and gouges can be bought either as nibs, which fit into a handle, or as solid chisels. Nibs can be bought in sets and are relatively cheap, compared with the chisel types. However, they are less satisfactory, particularly when dealing with large blocks, and are certainly not to be recommended for use on wood.

Fig 13 Cutting with the V tool

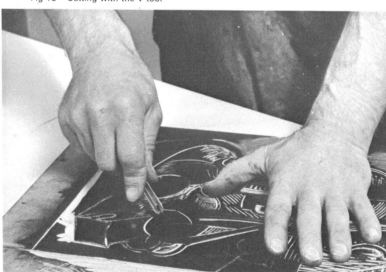

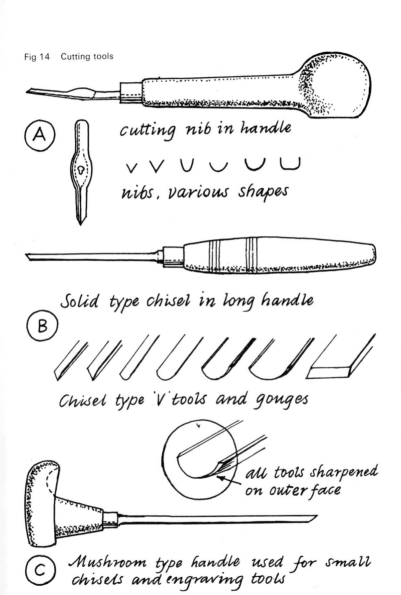

Fig 14 Cutting tools

(A) cutting nib in handle

nibs, various shapes

(B) Solid type chisel in long handle

Chisel type 'V' tools and gouges

all tools sharpened on outer face

(C) Mushroom type handle used for small chisels and engraving tools

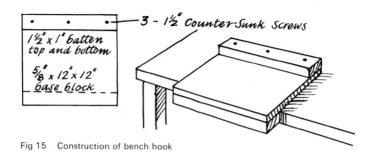

Fig 15 Construction of bench hook

When dealing with softer materials, they are perfectly suitable for classroom use.

A further advantage of the solid tools is that they can be more readily sharpened, and are pretty well indestructible. The nib tools break frequently, either because of bluntness, or because excessive pressure has been used to drive them through the material.

The gouge

These, like the V tool, are best as solid chisels, in which there is a much greater range of sizes. They are exactly the same kind of tool as used for wood carving, except that for the smaller V tools and gouges an engraving-type handle is used. The longer chisel handle is used on the larger gouges; mainly because these are used to remove the larger unwanted areas of the material and a mallet is used on wood to help drive the tool through the material (fig. 16).

Like the V tool, the gouges, differing as they do in section, can be made to produce very exciting textures depending on the length of cut and on the angle at which the tool is held. A slight rocking of the tool will produce a quite fascinating texture, see fig. 20D, page 27.

There is of course no fixed order of procedure. Although in theory each tool has a specific job for which it has been designed, it is only through your own personal experiment and application that you will fully discover the possibilities of each individual tool.

Apart from the conventional tools which I have described, there is no reason why you should not improvise other tools with which to create particular effects. For example you could use punches to indent shapes into a surface to give textural interest.

The graver

This is a tool mainly used for engraving on the end or cross grain of harder woods such as box, holly, etc. As you can see in fig. 17,

it varies in section from a lozenge to a square shape, the latter is also used for metal engraving.

The graver, when used on firm, close-grained materials, can produce lines of considerable fineness and fluency.

On softer materials – lino, hardboard etc. – this greater delicacy of treatment may be excitingly contrasted with the bolder cutting made by the knife and gouge.

Bench hook

A bench hook is used to help support the block during the process of removing large areas of background from around the areas to be left in relief. For this a mallet and chisel are normally employed (fig. 16).

The construction of a bench hook is very simple and is shown in fig. 15. It requires little more than a block of plankwood, plywood or blockboard 12 ins to 18 ins square and approximately $\frac{1}{2}$ in. thick, and two battens screwed at opposite ends, one on the top face and the other below. The battens should be about 2 ins × 1 in. in section.

Fig 16 Cutting with gouge and mallet using bench hook

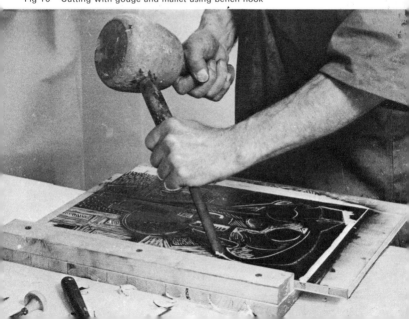

Care of tools

Fig 17 A–graver, shown with mushroom handle; B–square section; C–lozenge section. Typical marks made with tool on left

Sharpening

If tools are kept in proper condition, little difficulty will be experienced when cutting the various materials. The correct degree of sharpness is of vital importance if clean cutting is to be maintained with the minimum amount of physical effort. Blunt tools are the main cause of accidents.

Have an odd piece of the material on which you are cutting near at hand, on which periodically to test the tools for sharpness. Should there be any tendency for the tools to bruise or tear the material, they must be sharpened immediately.

To do this a carborundum or india stone is used first, with a little thin machine oil, to grind down any irregularities in the chamfer. In the case of a knife, the blade is held in the cutting hand and placed down flat on the stone. It is then raised slightly, so that the chamfered edge is lying parallel with the face of the stone. The tool is pressed down firmly with the other hand (fig. 18), and is then moved backwards and forwards along the stone until a clean, straight and sharp edge has been achieved. All that now remains is to remove the burr from the fine edge of the tool. A harder, closer-grained stone is used for this purpose, usually

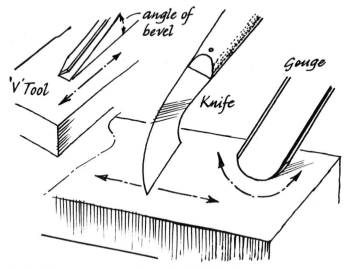

Fig 18 Sharpening tools on oil stone. Tools held firmly against stone and moved in direction of arrow

an arkansas or washita stone (see list of suppliers, page 101). The knife blade is once again laid down flat on the stone, but this time on the unbevelled or chamfered side, and passed two or three times along its length. The tool should now be tested on a piece of the material to ensure that it cuts cleanly.

The V tools are sharpened in much the same way, the chamfers being first ground on the carborundum or india stone as described. In order to remove the burr on the inner edges, a small V-shaped axolite stone (see list of suppliers, page 101) is used, with a few drops of machine oil smeared over it. The stone is placed in the V of the tool and, holding it firmly against one of the sides, moved gently backwards and forwards.
The opposite face is treated similarly.

When sharpening the round gouges, which vary considerably in section, a radial movement is generally used (fig. 18). As an alternative however, the stone may be rubbed against the chamfered face. The axolite V-shaped stone described above is also used for removing the burr on the inner face of the gouges, the finer end being used for the very small gouges, and the wider end, which is curved in section, for the larger ones.

Roll-up bag

In order to prevent the cutting edge of the tools from being damaged when not in use, it is advisable to buy or make a simple roll-up bag. This can be made quite easily, using a heavy piece of felt or canvas material, and a length of wide, strong tape stitched down at intervals to hold the tools in place (fig. 19). One final point worth remembering about the care of tools: if they are to be left for a period unused, smear a little light oil on them to prevent rust. This will also help to retain the cutting edge.

Fig 19 Roll-up bag

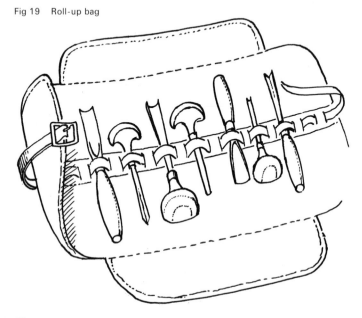

Treatment dictated by materials

The illustrations in the section which follows are intended to show how the nature of the various materials must dictate the character of the tools employed and the treatment.

Fig 20 Typical marks made with the various tools. A – knife; B – V tools; C – gouges; D – V tools and gouges. The free scribbled line was made with sharp pointed tool

a *b* *c* *d*

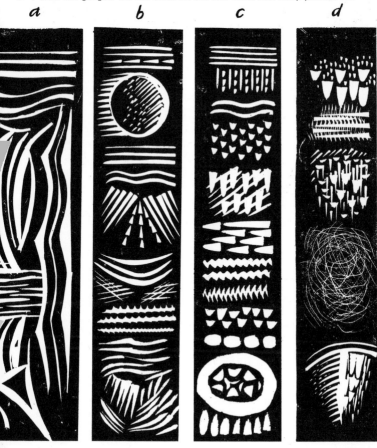

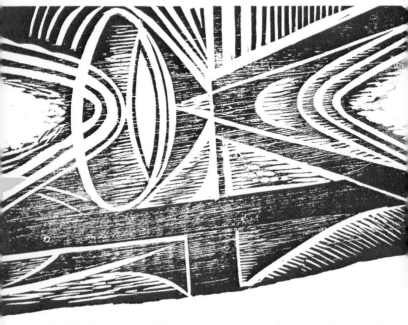

Fig 21 Cut made on plankwood, showing strong influence of grain on cutting

Plankwood

The above cut was done on an odd piece of pine wood. A print taken from the surface before cutting produced an irregular grey tone–the darkest area occurring along a horizontal band in the lower part of the block, caused by a fault in the grain. This band of darker tone suggested the arrangement of the principal lines, which were cut with the knife. The larger areas of white were removed with a medium round gouge; and a small V tool was used to open up the grain lines to give added tonal interest.

28

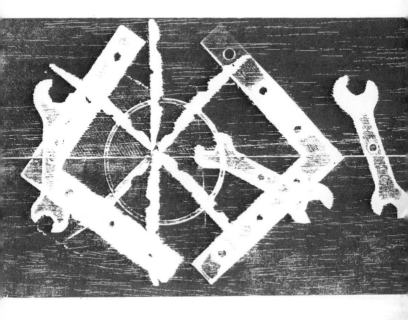

Fig 22 Relief block made by pressing shapes into balsa wood

Balsa wood

Impressed shapes: the soft, fibrous nature of balsa wood does not lend itself very readily to direct cutting with the knife or gouges but, as seen from the example above, shapes can easily be impressed into it. These can either be hammered in, using a piece of hard material placed over them (plankwood, hardboard, etc.), or sunk into the balsa wood by using a press, if available.

Textures of various kinds can be produced similarly, by using nails and differently-shaped tools.

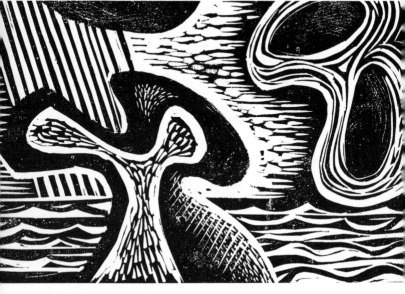

Fig 23 Lino cut, showing free, crisp quality of cutting with knife and gouges

Lino

A knife was used for cutting round the central shapes, also for the white wave lines in the lower part of the design, and for cutting the black lines moving upward towards the left. The V tool and various-sized gouges were used for the different textures, and for the free cutting within the shape to the right. Sandpaper was used to soften down the edge of the dark shape in the top left-hand corner.

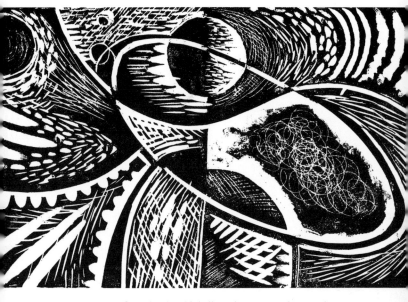

Fig 24 Hardboard cut. Cuts cleanly with knife and gouges, as long as these are kept sharp

Hardboard

As may be seen from the above print, hardboard, despite its resistant nature, can be cut quite freely with a knife and gouges, provided they are kept well sharpened. However you will notice that apart from the main lines defining the shapes, which were cut with the knife, the remaining cutting, with V tools and gouges, is less sharp and crisp in character, and is used to develop textural interest. This is due to the fibrous nature of the material, which has a tendency to tear when using the hollow tools.

The finer hatched lines and scribbled texture in the central area were produced by scratching with a sharp metal point. The broken edge around the scribbled texture was made by tearing the top layer of the hardboard back.

Softboard

The block from which this print was taken was cut with both knife and gouges, and illustrates the nature of the material. Owing to its relative softness, this can only be cut cleanly with a sharp knife, the gouges producing a vigorous torn effect, as you will see. Punch marks, produced with the use of various wood and metal tools, were added to give additional colour and textural interest.

The natural textured surface of the material when inked up can also be seen clearly in this print.

Fig 25 Softboard cut, made with knife and gouges. Punch marks produced with wood and metal tools

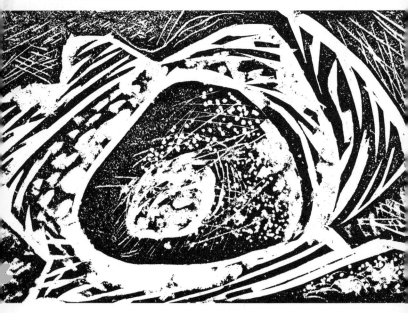

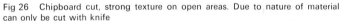
Fig 26 Chipboard cut, strong texture on open areas. Due to nature of material can only be cut with knife

Chipboard

Like many other types of composition board, chipboard possesses an exciting surface texture which gives natural colour to the surface.

Controlled cutting is possible with the knife, which was used to define the various shapes. Round gouges were used to remove the larger areas of white and bolder texture, and the V tool was used for developing surface interest and tone.

With the rapid development in recent years of natural and synthetic fabricated sheet materials for building and industrial purposes, the printmaker's means of expression has been greatly widened. I have described the potential qualities of only a few of the materials available – those that are relatively commonplace and which I have experimented with myself.

By exploring in your own personal way as many of these new materials as possible, fresh exciting qualities may be discovered with which to enlarge your scope of expression.

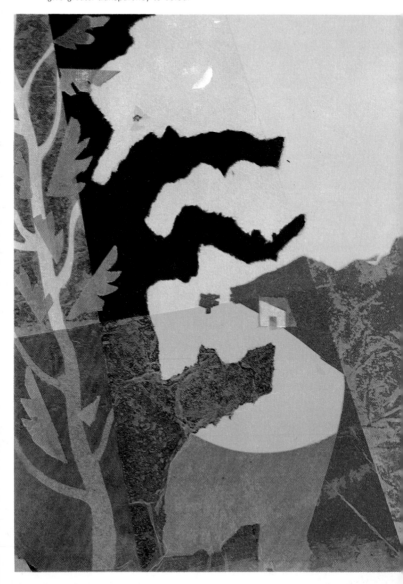

Fig 27 Paper design. Coloured tissue paper overlays used with paper varnish to give greater transparency to colour

Design

Design means the arranging of the various elements of a composition in such a way that the fullest expression is given to the idea which the artist wishes to convey.

Whether anything in the nature of a paper design is done before the actual cutting of the block usually depends on the individual artist–some find it difficult to realize their aims without a good deal of preparatory note making, whilst others prefer to find the solution to their ideas in a more direct way, by working with the tools and materials, in which case little more than a few brief scribbles might prove sufficient.

It is important to remember that however simple or elaborate one's notes may be, they have ultimately to be translated in terms of the particular medium–whether it is wood, lino, or any other material. If the resulting print is to be of a truly creative kind, the paper design can only serve to give direction to the work, never as a final statement to be copied slavishly. The materials and the tools used to create the image have their own character, which must be respected if one is to achieve the fullest expression from them.

If we assume that the idea is to be expressed in terms of black and white with, say, the addition of textures of various kinds, a note made with a pen or brush and indian ink, or perhaps a tone study made with watercolour to indicate the general arrangement, would be quite adequate.

Once a satisfactory design has been arrived at, a piece of

Fig 28 Studies of shell

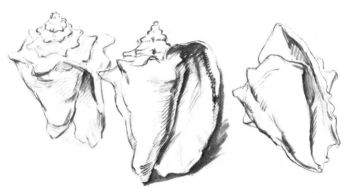

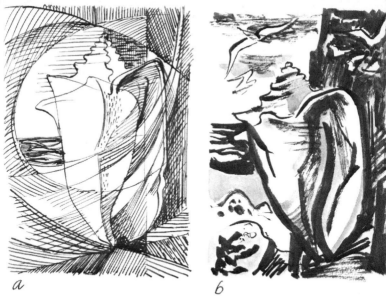

Fig 29 Two paper designs. A uses line to explore rhythms in shell form; B is a tone arrangement made with a brush

tracing paper can be placed over it and the main lines of the design traced through and reversed down onto the block (see fig. 37, page 44).

Cut and torn paper shapes can prove a useful way of experimenting with a design, offering considerable freedom of arrangement. This is a method which can be used very effectively in the development of a colour design, as I will explain later (page 55).

As I have said, artists work in different ways. With experiment everyone finds the method of working which suits his requirements.

The treatment of your design will depend upon your personal reaction to the subject. A head, for example, could be expressed in terms of pure black or white line. On the other hand you might feel that the particular form and character of the subject demanded a more powerful use of black and white shapes to give the fullest expression to your idea. Design has to do with just this kind of consideration.

The surface quality of the material on which the cutting is to be done will also need to be taken into account.

If an open-grained wood or textured-surface material is to be used, every effort should be made to exploit these qualities in the design. For this reason it will be advisable to take a print in black

Fig 30 Free brush drawing, using indian ink

or darkish colour before the cutting, in order to examine the surface pattern more carefully.

I should like to stress that although quite delicate cutting is possible using the finer tools on certain of the more compact materials, the relief print, broadly speaking, is best suited to formal and more abstract treatment, in which a bold use of colour and shape are used to give expression to an idea. Scale too is an important factor. A print contained in an area of a few square inches will require a very different treatment from one in which the idea is expressed in an area of much larger proportions.

Colour

With the introduction of colour the problems of design become more complex. Whereas in the case of the black and white, or the single colour print, the interest and varying emphasis will depend upon how expressively the shapes and textures are used, colour affects us in other ways. For example a particular yellow seen in a field of deep blues and purples will stand out very strongly in a design. It will also be noted that the degree of emphasis given to a colour becomes greater as it becomes smaller in relation to the surrounding colour areas. This rather curious inverse behaviour

of colour is important to remember as a means of creating particular emphasis within a design.

By experimenting freely with colour, you will discover for yourself how colours react upon one another.

Try to express your ideas with as few colours as possible. In this way you will gain a greater understanding of colour construction and learn to exploit each individual colour by under- or over-printing with other colours, as a means of extending the range and harmony of your design. Fig 41, page 51, illustrates the possible range of colour values that can be achieved by the over-printing of three basic colours and black.

One final point I should like to make, if it has not already become self evident from what I have said about designing, is that designing a print cannot be considered as a separate stage which, once complete, leaves only the cutting of the block or blocks to be done. Designing may begin on paper, as I said earlier, or directly with the cutting tools on the material, but if the final print is to be of a really creative kind, the process of design must continue through every stage of cutting and printing until the final proof is taken.

Treatment of subject

The treatment of subject has to do with the individual artist's reaction to it. It is a direct reflection of the artist's personality, and his response to the world around him.

In this chapter I hope to describe briefly and to illustrate the way in which the treatment of a subject can be used to convey very different kinds of experience.

Figs 31, 32 and 35 are prints based on the same subject matter, but treated differently. Fig. 31 might be described as representational or naturalistic in treatment. The main interest in this print has to do with the atmosphere created by the light acting on the different surfaces of the objects in the group.

If you compare this print with fig. 32, you will note that the treatment has been simplified, so as to produce a bolder arrangement of shapes and textures, sacrificing the descriptive and literal aspect to pattern and decorative effect.

In fig. 35 the same elements have been used, but you will observe that an even greater liberty has been taken in the treatment of the subject. The direct visual experience has been deliberately distorted in order to express a wider experience of the subject. It has become more abstract.

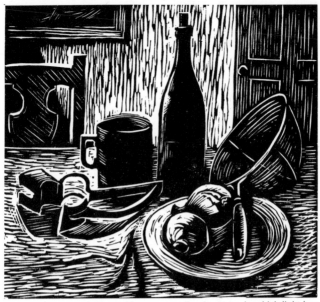

Fig 31 *Still Life* (lino cut). Treated in representational manner, in which light has been used to evoke atmosphere

Fig 32 *Still Life* (lino cut). The same subject matter, but treated in a decorative way

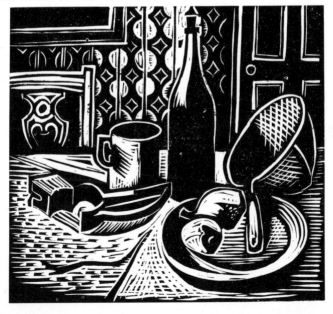

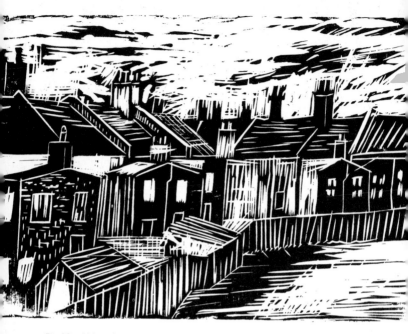

Fig 33 *Urban Landscape* (woodcut by student). Strong, vigorously-cut block, expressing dramatic mood in subject

Had colour been used in each of these prints, a similar consideration about treatment would have been necessary. For example in fig. 31, in order to be consistent, colour would need to have been used in a descriptive way to heighten the atmospheric effect, and as a means of identifying the different objects, whereas in figs 32 and 35 colour would require to be used in a more formal and decorative way. The two remaining prints which I have chosen to illustrate the subject of treatment (figs 33 and 34), are both based on the theme of urban landscape.

If you compare these prints you will note an interesting contrast, both in the aspect of subject chosen, and in the manner of treatment. These differences reflect the individual artist's response to his subject.

In fig. 33 the free, vigorous cutting has resulted in a strongly-dramatic mood, in which space and atmosphere are expressed.

In contrast, fig. 34 shows the artist's preoccupation with decorative and formal qualities. Here the pattern and textural interest of the subject have been extracted to produce a very pleasing design.

Printing equipment

Rolling-up slabs

These are required for rolling-up the printing ink so as to distribute it evenly over the surface of the roller. Any hard, suitably-thick, smooth-surfaced material may be used for this purpose, provided that it is non-porous. Glass (preferably plate glass) is particularly suitable as, if placed on a sheet of white paper, colour values can be judged more correctly. It is also less likely to be scratched by the palette knife. Other materials which may be used are zinc or aluminium sheeting, plastic-faced hardboard (white if possible), old lithographic stones, and any similar smooth, non-porous material.

The size of your rolling-up slabs should be no smaller than 10×8 ins, and it will be advisable to have at least three, especially if you intend to use colour.

Fig 34 *Urban Landscape* (woodcut by student). Here texture and pattern have been interestingly used to achieve a pleasingly decorative effect

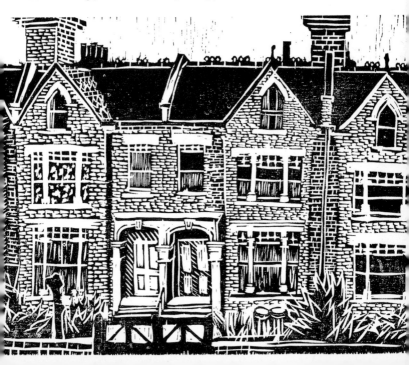

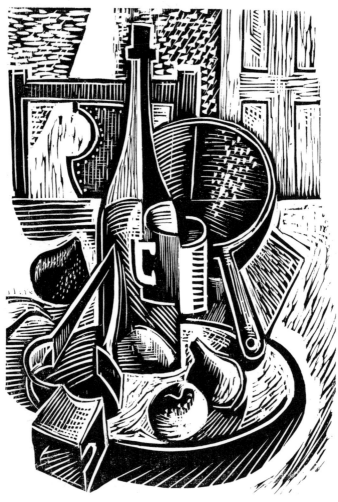

Fig 35 *Still Life* (woodcut). This uses the same subject matter as figs 31 and 32, but treats it in an abstract way

Rollers

The roller, or brayer, is used to transfer the printing ink from the inking slab to the printing surface of the cut block. Rollers may be purchased in differing sizes, construction and material. The smallest and cheapest are rubber covered over a wooden core,

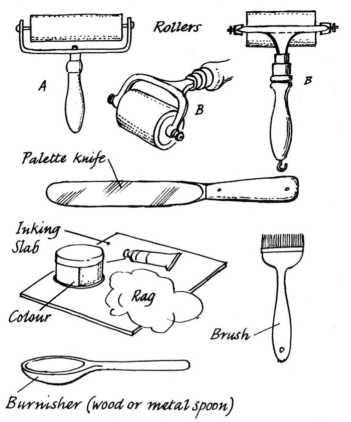

Fig 36 Printing equipment: A – rubber roller; B – composition or gelatine roller

mounted in a simple metal frame. These are about 1 inch in diameter and up to 4 ins in width. More expensive ones are made either of gelatine or plastic. Plastic rollers are the most expensive, but an excellent investment if you can afford them. They are usually of a more robust construction than the rubber rollers (fig. 36), the roller being mounted in a solid brass frame with a good stout wooden handle. The roller varies in size from $1\frac{1}{2}$ to 2 inches in diameter and up to about 7 inches in width. Both the gelatine and plastic rollers are softer than the rubber rollers, and therefore more sensitive, which makes it possible to ink-up different levels of a material in one stroke. For example, let us suppose we wish to take an impression from a piece of weathered timber, and want the ink to be transferred not only to the raised hard grain, but also to the lowered surface of the softer fibre of the worn down wood.

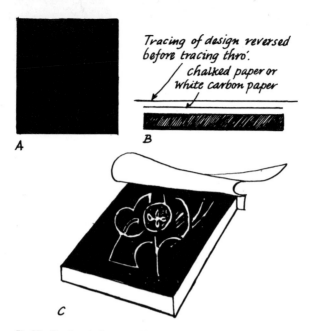

Tracing of design reversed before tracing thro'.

chalked paper or white carbon paper

A

B

C

Fig 37 Tracing design onto block. A–block darkened with indian ink; B–order of placing tracing and chalked paper down; C–after tracing through with hard point, tracing turned back and chalk paper removed

A soft gelatine or plastic roller, inked-up with just the right amount of ink, will do this, with very little pressure required.

A further advantage of the softer roller is that due to its fine, compact surface, it is possible to take up an image onto the clean roller from an inked surface, and transfer it onto the printing paper. This is known as offsetting (see figs 94–96).

Rubber or plastic rollers may be used for both oil and water-based inks. Gelatine rollers are only suitable for oil-based inks, and require to be kept in a cool place away from any source of heat, to prevent distortion.

Palette knives

For mixing colours, and for spreading them onto the inking slabs, a palette knife is used (fig. 36). A convenient size would be one with a 6-in. blade, and it will be found an advantage to have more than one, especially when dealing with colour prints. This saves time spent cleaning the knife when changing from one colour to another.

Preparing and cutting blocks

Whatever the material you choose to cut on, whether it is wood, lino, hardboard etc., a certain amount of preparation will be necessary before the actual cutting can begin.

For reasons of convenience I propose to describe the process for the single-block print only; later I shall be dealing with the multi-block method, as used for the colour print (page 50).

Assuming that the design is to be cut within a regular shape, the wood, lino etc., will need to be cut squarely to the size required. For this purpose a set square and T-square should be used, to ensure that the corners are truly square. This is even more important where a number of colour blocks are used together.

Having cut the block to the required size, in certain cases it will be helpful to treat the surface in some way, in order to see the cutting more clearly as the work proceeds.

In the case of lino I have usually found that a little indian ink or black poster colour rubbed lightly over the surface is sufficient to give contrast to the cut line. The beginner will find this particularly helpful, as it is difficult at first to visualize the weight of the line and the tones that will be produced in the print. Darkening the surface will also help in the tracing stage.

The same method of darkening the surface of the block can be used for hardboard and any similar and relatively non-porous material. In the case of soft plankwood however, it would be unwise to use any form of water-based colour or ink, as this will tend to sink into the surface and affect the softer fibres of the wood. As an alternative, a softwood block may be rolled-up thinly with a suitably-dark printing ink, the surplus wiped off, and the ink allowed to dry before tracing or drawing the design onto it.

As I have said earlier, it is not essential to work from a paper design. If you feel sufficiently confident, you may choose to work directly on the block. The beginner however will find it helpful, at first, to have some form of reference to work from, even if this is only a brief indication of the main shapes. A further advantage of making a tracing is that if your design is to appear in print the same way round as in your paper design, it will have to be reversed down onto the block, and a tracing will make it easier to do this.

Having made your tracing with a reasonably hard pencil on a piece of tracing paper an inch or so larger all round than your design, rub in some powdered chalk on the drawn side, dust off the surplus, and reverse it down onto the block, which you have cut to the correct size.

A hard pencil or ballpoint pen can be used to trace through the

design. Your tracing must be firmly attached to the top edge of the block – tape or drawing pins (thumbtacks) can be used – before beginning to trace through (see fig. 37).

Cutting

Before starting the cutting, the chalk lines on the dark surface of the block should be reinforced with white poster colour, using a brush. This will ensure that during the cutting and printing stages the design will remain permanently on the block, assuming that an oil-based printing ink is used. The oil will not affect the poster colour, which is water-bound.

With either a knife or a V tool cut around those parts of the principal shapes where you feel that a firm boundary is required. Do not work in a mechanical fashion by cutting what will appear as a white line around all the shapes. Your design will be richer and more interesting if varying emphasis is given to contours, especially if it is in terms of black and white (see fig. 23).

Having cut as much of your design as you feel is necessary to

Fig 38 Inking the roller

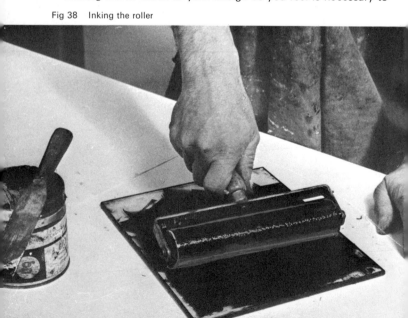

give reference to the main shapes—the larger areas of white might also be roughly cut back at this stage—a print should be taken to see how the work is progressing. For the beginner in particular it is wise to take proofs fairly frequently. In this way he will become familiar with the true character of the cut image more quickly, and with the marks made by the various tools, and less likely to follow his paper design slavishly—a danger which I have mentioned earlier.

In the case of the tone, or black and white relief print, the qualities which I think particularly important have to do with shape, texture and decorative interest. Therefore, having established the principal lines of your design, consider how the various shapes within the composition might best be treated in order to give the fullest expression to your idea.

By including areas of both black and white, the different textures which you will achieve with the use of the various tools will be given greater richness. Using a similar counterchange in the line-parts of the forms—some parts defined with black, other parts with white—varying emphasis will result, helping towards a more satisfactory unity.

Fig 39 Rolling-up the block

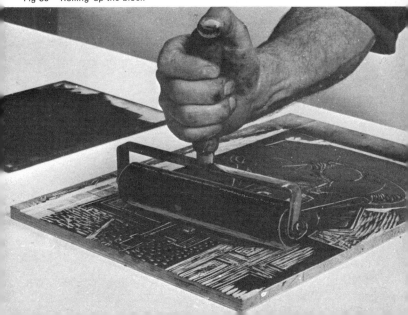

Printing inks

Oil-based colours

Oil-based colours, generally known as block printing inks, can be purchased from any large artists' suppliers.

These are specifically designed for printmaking; and possess, among other things, a greater viscosity or tackiness than ordinary artists' oil colours, which makes them easier and more pleasant to roll-up. They are normally supplied in tubes, but can also be bought in larger tins from certain suppliers. Colour keeps best in tubes, but is less economical.

An ink used in commercial printing, known as letterpress ink, will also be found particularly suitable for relief printing, and is used widely by printmakers. It is supplied in tins of one pound and over, and works out more cheaply than tins of block printing ink.

Fig 40 Printing the block, using a metal spoon as burnisher

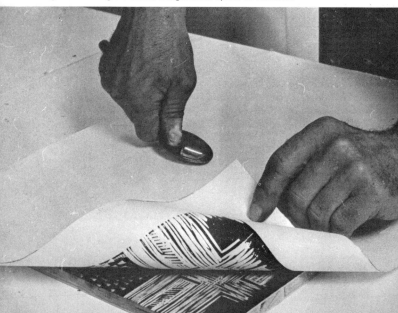

Ordinary artists' oil painting colours, mentioned opposite, can be used very successfully in printing, either on their own or in combination with printing inks. Being more finely ground than most printing inks, they can be used in very delicate glazes and are especially useful in over-printing. Due to the fact that some of these colours possess a rather higher proportion of oil than others, some difficulty may be experienced in rolling them up. This can generally be overcome by placing the amount required on a sheet of blotting paper to absorb the excess oil. Oil-based inks vary in the degree of transparency they possess. In order to test this, it is advisable to print on a perfectly white ground using a small block of lino or wood. By inking the block up and printing it in the different colours you will quickly recognize which are the more transparent ones. The white of the paper will heighten the tone of these and give them greater brilliance, the more opaque ones will be less affected.

These qualities – transparency and opacity – are both extremely important to the printmaker as I hope to illustrate later.

Watercolour inks

Until quite recent times, water-based colours were traditionally used for block printing, and they are still quite widely used today, particularly in the eastern countries from which the earliest block prints originated.

Watercolour inks possess greater transparency than oil-based inks on the whole, but less intensity. In eastern countries the dye or pigment is usually mixed into rice paste, and the colour applied with a brush to the block (plate). In the west however, a particular gum is used, which acts as a binder and facilitates the use of the roller for transferring the colour to the block (plate).

Due to the rapid evaporation and absorption of the water content, watercolour inks dry very quickly, which means that colours can be printed one upon another in fairly rapid succession if required – an advantage especially when dealing with print-making in classes involving young children, where the time factor is likely to be important.

The colours are usually sold in tubes of varying size but, as in the case of the oil colours, they can be bought in larger quantities made up in tins. Water-based colours should not be mixed with oil colours, but will be found to work perfectly well as an underprinting to oil colour. Very interesting and rich effects may be achieved by combining them in this way.

Colour printing

A colour print may be produced in one of a number of ways:

Multi-block method

The multi-block method, in which a block is used for each separate colour, is traditionally the oldest and still the most frequently employed method of colour printing. Some of the finest examples of colour printing produced by this method are to be found among the superb Japanese prints of the eighteenth and nineteenth centuries.

The success of a print of this kind depends very largely upon the manner in which the individual blocks are designed and related one to another–each must play its part in helping to give unity and coherence to the whole.

KEY BLOCK

The role that this block plays in the final print will vary according to the conception and treatment of the design.

Any one of the colour blocks may serve to act as a key, which need not be the darkest or the most dominant colour.

As the term implies, the purpose of this particular block is to give reference to the various shapes and colour areas within the design. Usually this block is cut first, using one's colour sketch or paper as a reference, or drawing onto the block and cutting directly.

However, if one is to exploit the full potential of the colour print, it is unwise to commit oneself in the early stages, to the extent of completing the cutting of any one block. The possibilities of your design will be more readily seen as each of the blocks is developed in the cutting and printing stages.

Work tentatively, cutting from your first block, which is to act as a key, only as much as you feel necessary as a guide to the cutting of your other blocks.

Once the stage has been reached when you feel satisfied that there is sufficient information, transfer a proof of this key block onto your remaining blocks (figs 44–46).

In fig. 44 a partially-cut key block is shown being printed in a registration frame, which ensures that the separate colour blocks are positioned correctly in relation to one another for printing. This is very simple to construct, as shown in fig. 43.

If you now look at fig. 46, the final stage, you will see how this proof, taken on thin tissue, has been transferred onto an uncut block. A white printing ink was used in this case, so that it would

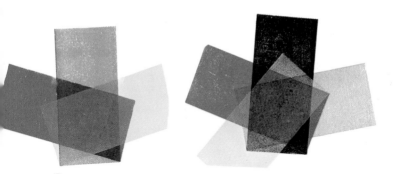

Fig 41 Colour overprinting. A – shows the three primary colours in overprinting;
B – the same colours overprinted on black

Fig 42 *Tomato Plant*, three-colour print (see Figs 47–49)

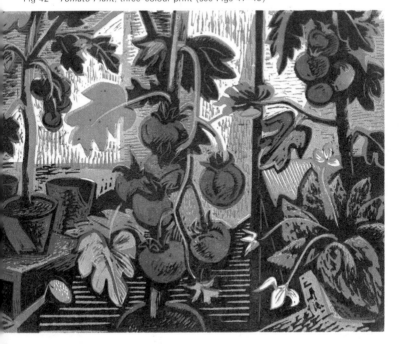

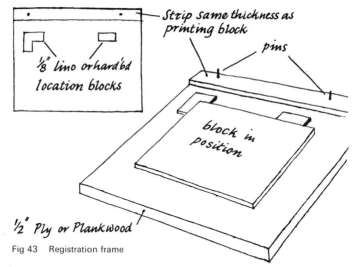

Fig 43 Registration frame

show up clearly in the photograph, but the colour used is of no importance providing it will contrast sufficiently with the tone of your blocks.

More than one impression may be taken from a proof of this kind, assuming the block has been inked-up heavily enough and that the proof is taken on a non-absorbent paper.

After the first proof from your key block has been transferred, or off-set, onto your second block, by burnishing with a roller, or with a ball of soft rag, the proof is lifted and the third block placed in position against the location blocks. Once again the proof is lowered and the proof burnished as described. The process is repeated in the same way for any further blocks. Should the proof become too dry after the second or third transfer, a fresh proof from your key block can be taken.

One important point to remember, especially when using thin printing papers, is that they should be reinforced with small squares of gummed paper or cellotape (Scotch Tape) before pressing them over the locating pins. This is to prevent tearing, which would affect the registration.

Allow the blocks to dry, or dust them with a little french chalk or talcum powder to dry off the surplus ink, before cutting.

Any further information you may require for the cutting of your blocks, which is not contained within the key proof, will need to be traced through from your paper design or drawn directly onto the blocks. However, once the cutting of your second block has been sufficiently developed, it can be used in precisely the same way as your first block to transfer information onto any of the other blocks.

By transferring proofs from one block to another in this way, rather than attempting to follow a paper design, a more truly creative work will result.

A proof may be taken at any stage of the work, in order to see how the blocks are working, one with another, using the registration frame.

Experiment freely with your colours, and with the order of printing your blocks. Remember that oil, as well as water-based printing inks, can be made more transparent, if required, by the addition of a special reducing medium, which your colour supplier will advise you about.

Fine glazes of colour can be achieved in this way, even colours which are inclined to print opaquely can be made less dense by adding a reducer.

Try using both opaque and transparent colours in your print. Quite a different result will be achieved, for example, if you print your more opaque colours as an under-printing to your transparent ones, than if you reversed the order.

Use dark colours beneath light, and light colours beneath dark. Working with only a narrow range of colours, three or four perhaps, see how you can best exploit them in under-printing and over-

Fig 44 Taking print from key block, using white ink and thin tissue paper, with block positioned in registration frame

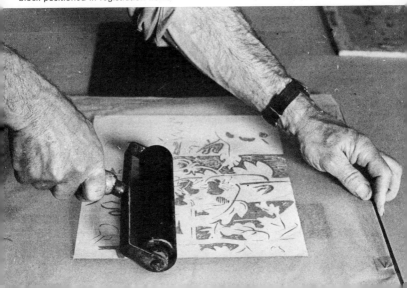

printing to get the most out of them. Black can be used to give added strength and richness to a print, both for under-printing and for overprinting. Fig. 41B shows it used as an under-printing with the three primary colours—red, yellow, and blue.

Aim to express your idea with as few colours as possible. Remember that overprinting your three primaries alone will produce seven distinct values (see fig. 41A), which is not including the white of the printing paper. By adding only one further colour the range would be doubled.

PREPARING COLOUR DESIGN

For the preparation of your paper design, I would recommend the use of watercolours or coloured inks. Using them boldly in washes, one upon another, will help you appreciate something of the effect possible in the overprinting of your colours.

What form your paper design takes must remain a personal matter, and will depend entirely on what you feel will serve to give you the information you require. Do not over elaborate your design. If it is kept simple there will be less danger of following it too closely in the cutting of the blocks; which is very important if the print is to be a creative work, and not a mere copy or reproduction of your paper design.

Fig 45 Transferring print of key block onto second and third blocks

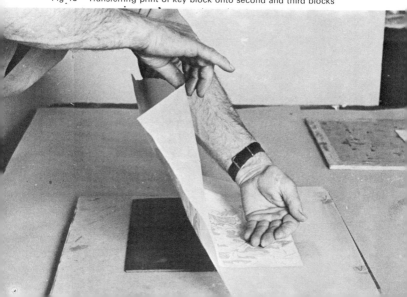

The colours used in your paper design will serve as a basis for the cutting of your blocks—giving reference to the colour areas. But remember that once the cutting has been taken far enough to make it possible to take a proof, using your blocks in combination with one another, you will want to experiment with the colour and the order in which the blocks are printed before you decide on the final colour arrangement.

Coloured papers, especially the thin coloured tissues, can be usefully employed as an alternative to watercolours or coloured inks for the preparation of a paper design. This method of working allows considerable freedom of approach, and could prove especially useful for those who lack experience and confidence in putting their ideas down on paper. The particular advantage of this method is the flexibility it permits in the cutting up and arranging of the coloured shapes to form a basis for the design. The effect of colour overprinting is readily suggested by the overlaying of the coloured tissues, which are reasonably transparent. A little gum or rubber solution (rubber cement) can be used to fix them down once you have decided on the arrangement. In combination with a paper arrangement of this kind, inks, watercolours or crayon could be used to develop the design.

An example is shown in fig. 27.

Fig 46 Removing print from block

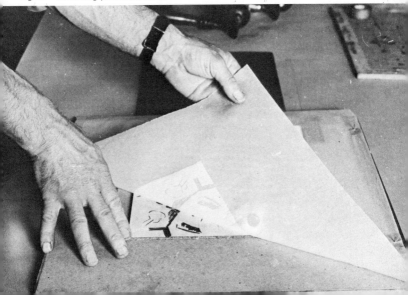

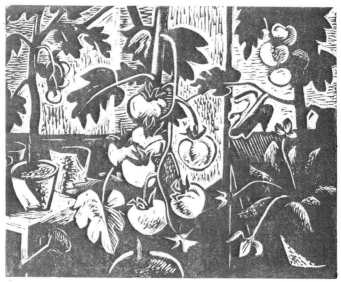

Fig 47 *Tomato Plant*, key block, blue-green

Fig 48 *Tomato Plant*, second block, orange-red

56

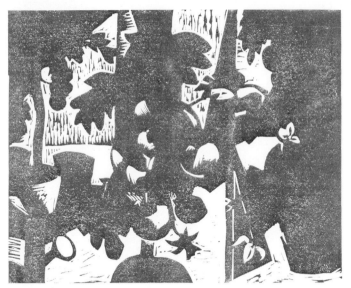

Fig 49 *Tomato Plant*, third block—ochre yellow

Single-block colour print

This method, which makes it possible to produce a colour print from a single block only, has in recent years been widely used, especially in schools, and has much to recommend it. It encourages a very spontaneous approach to design; and it does away largely with the problems involved in the registering of separate colour blocks—a considerable advantage to the beginner.

Briefly the method involves the cutting away between the printing stages of further areas of lino, or whatever the block material may be, until, if required, only very small areas may remain to print the final colour. Fig. 80 illustrates very simply the principle which underlies the single-block, or 'waste method' as it is sometimes called.

Here a disc of lino has been used. After cutting away a small area from the centre, the disc was inked up in yellow and a proof taken.

Before inking up in the second colour, red, further cutting was done enlarging the cut away area in the centre. The process was repeated to give a boundary to the final colour, which was printed up in blue. Oil printing inks were used for this experiment, a reducer being used in mixture with the red and blue, to give greater transparency. From this simple example it will be seen

Fig 50 Single-block colour print, print taken after first stage of cutting

that basically there can be only one pure colour, or colour un-
affected by overprinting, in a print produced by this method. This
is a limitation which has to be recognized in designing for the
single-block colour print. A further restriction which must also
be taken into account is the fact that as more of the printing
surface is removed after each of the printing stages, the individual
colour areas in the print are destroyed. This means that the order
in which the colours are printed cannot be changed, although, as
I shall explain, it is possible to extend the range of this type of
print in other ways.

 Although I would recommend that you work as directly as
possible on the block, a simple colour note might be made first,
to help clarify your idea.

 Use watercolour, coloured inks, or coloured tissue paper, to
build up your design.

 In order to get in your paper design something of the quality
that will be achieved by this method of printing, you will need to
take into account the fact that, with the exception of your first
colour, to which white may be added, all further colours will be
the result of overprinting.

Fig 51 Print taken after second stage of cutting

If therefore you work with your colours, using them transparently or opaquely one upon another, leaving parts of the underlying colours to show through, remembering that each progressive reduction in the colour area implies a cutting away of the printing surface of the block, you will find it easier to translate your idea in terms of the method.

The fact that it is possible to print with this method an almost unlimited number of colours is a danger that can readily lead to confusion in a design. Aim to express your idea with no more than three or four colours, particularly in your early experiments. As you gain more knowledge about colour and its behaviour in mixtures and overprinting, you will find it possible to exploit a greater number of colours when the need arises.

Having decided in your paper design on the disposition of the main shapes, take a tracing from it, indicating also the rectangle in which the design is contained.

The next stage will be to cut your block to the correct size. Lino, hardboard or a similar grainless material which may be cut freely, will be best suited to the method. If any white is to appear in the print it will either have to be cut away as a first stage to

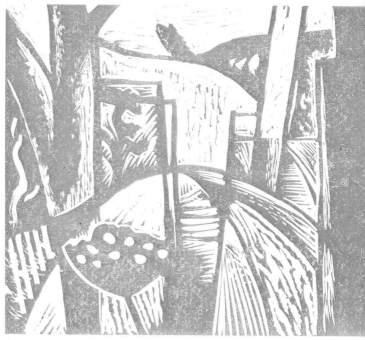

Fig 52 Print taken after third stage of cutting

leave the paper, or used as an opaque value over your other colours. If the white of the printing surface is required, trace down the shapes onto the surface of the block as suggested in fig. 37 and start by cutting these areas away. Now the first stage of the printing must begin before any further cutting is done. A registration frame can be used, as shown in fig. 43, or the block can be placed down onto the print area for each successive printing, using the corners as a guide. This will depend on the degree of accuracy required in the registration of the shapes.

As the effect of your overprinting will depend on the order in which the colours go down, careful thought is required at each of the cutting and printing stages.

Remember that the colour you choose for your first printing will act as a ground for all your other colours, and cannot be reversed once further cutting has taken place. However, as I suggested earlier, there are ways of extending the colour possibilities in a print of this kind.

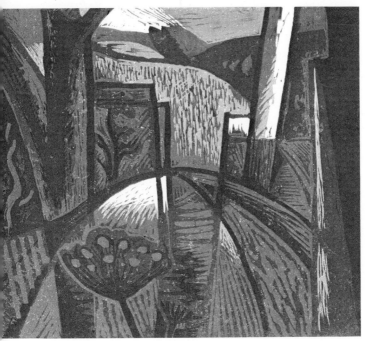

Fig 53 Final print, taken after further cutting – showing four-colour overprinting

In the first place, different colours may be used at each stage of the printing. For example, if instead of restricting your first printing to one specific colour, you take two, or three, or more sets of prints in different colours or variations of the same colour, this will immediately enlarge the colour range of your prints.

If the same procedure is adopted in the printing stages which follow, you will finally have a number of sets of prints of different colour arrangements.

Again, by exploiting the transparency or opacity of colours, an added richness and excitement will be given to your prints. Coloured or toned papers may also be used to print on.

As a method of colour printing, the single-block technique will not necessarily meet all your requirements, but using it in an experimental way will prove most profitable as a means of extending your knowledge of colour in design. In figs 50–53 various stages are shown in the development of a print of this kind.

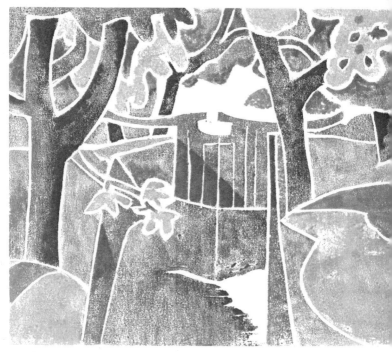

Fig 54 White line block, cut on wood, colours applied with brush

White-line method

This is not a method which is very widely used. Like the single-block method, it offers a means of producing a multi-colour print using a single block. But here the similarity ends. In the single-block and multi-block methods, the colour structure of the print depends very largely upon the overprinting of the various colours. Using the white-line method no overprinting is possible–unless of course further blocks are added.

As will be seen from fig. 54, the white line acts as a boundary to the colour areas, which were inked up by hand with a brush using a diluted form of oil-based printing ink.

The success of this method, which much resembles the qualities of stained-glass design, depends very much upon strong formal treatment of line and colour. Despite its considerable limitations, it is a method capable of rich and subtle effects. This is due principally to the fact that greater control is possible in the treatment of the colour areas when using the brush than when using a roller.

The composite print

The colour print in fig. 62 was produced mainly to illustrate a method of working when using a number of units which differ in size and material.

The method is especially useful in the construction of collage prints, in which found objects, for example natural forms such as wood grains, bark, leaves etc., as well as metal forms, fabric and paper, and other such materials (which to the layman would be generally regarded as scrap) are inked-up and printed together, or separately, using a simple registration block as in fig. 55.

This registration frame is basically the same as the one used for the three-colour multi-block print (fig. 43), except that the base block, in this case a piece of $\frac{1}{2}$-in. chipboard, has been covered with a sheet of thick cartridge paper, fixed down with drawing pins (thumbtacks), and the small locating blocks somewhat differently arranged. It will also be noted that the top batten, on which the printing paper has been pinned down, has been increased in thickness ($\frac{1}{2} \times \frac{3}{4}$ in. approximately), in order to bring it up to the level of the blocks.

Three of the blocks used to produce this print were mounted up on soft fibre board, partly for convenience of handling, but more especially to give them uniform height with the fourth block, a piece of $\frac{1}{2}$-in. plywood.

Fig 55　Lino block shown in registration frame, inked-up in two colours. Paper positioned on pins (tacks) ready for printing

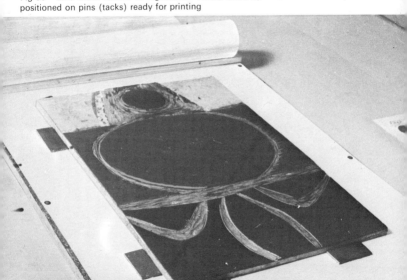

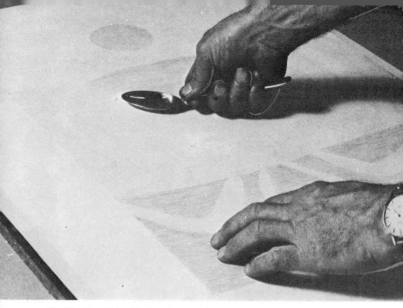

Fig 56 Burnishing block, using metal spoon

Fig 57 Removing print

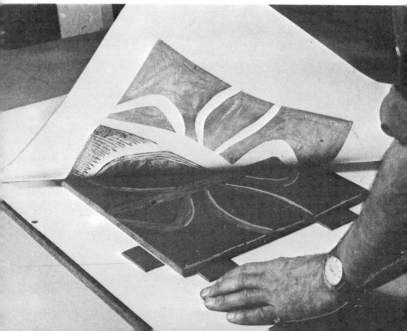

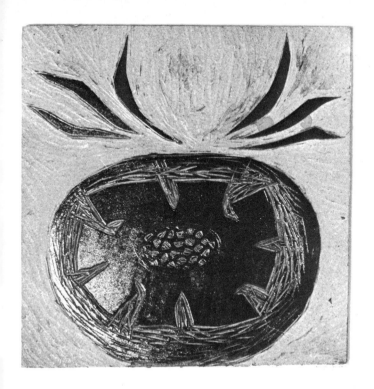

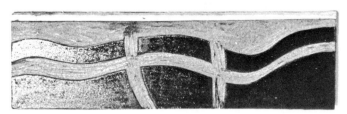

Fig 58 Hardboard blocks

The order in which the blocks were printed is shown in figs 55–60. The first block is lino, fig. 55, and is shown inked-up in two colours, an orange in the disc at the top, and in the lower area, and a mixture of french blue and veridian green in the centre. Any colour block may be inked-up in this way, providing the areas are sufficiently isolated from one another to make it possible to ink them with a roller–different-sized rollers can be used for this purpose.

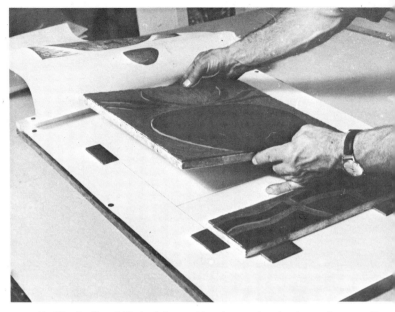

Fig 59 Hardboard blocks being positioned on registration frame. Note pencil lines used to help fix position of top block

Fig 60 Plankwood grain block in position ready for printing. Paper mask shown placed down onto inked block

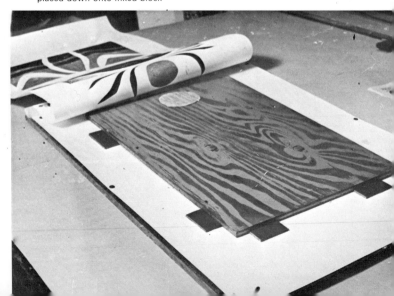

In the second stage, fig. 56, the paper has been lowered onto the block, and is shown being hand-printed using a metal spoon as a burnisher.

Fig. 59 shows two hardboard blocks being positioned; note the pencilled lines used to register the central block. A tracing of the paper design was used to fix the position. These blocks were inked-up in a dark colour, a mixture of black and crimson lake. In the final stage, fig. 60, a plywood block, the hard grain having been brought out strongly by rubbing it well down with a wire brush, is shown in position ready for printing, inked-up with a mixture of yellow ochre and burnt sienna. A small paper mask, cut from thin tissue has been placed down in the top area of the block. This has prevented the colour of the grain texture from printing over the blue-green disc and within an area to the left of it. In order to ensure that the mask was placed in the correct position after the block had been inked-up, registration marks, using indian ink, were made on the block using a tracing from the paper design. These showed clearly through the printing ink.

This method of using masks as a means of controlling colour in a print, without actually cutting the areas away from the printing surface of the material, is particularly useful when dealing with collage printing, as I shall explain later.

If you have understood clearly the process described above, it should be obvious that with the addition of a sheet of white paper fixed to your registration block, any relief block, whether regular or irregular in shape, can be reasonably accurately positioned for printing. All that you need to do is to mark its position on the base paper so that it can be located when required.

To help in the printing stages, blocks should be of the same thickness. When using lino, hardboard or similarly-thin materials, in conjunction with thicker blocks such as wood, etc., they will need to be mounted on a suitable material so that their printing surfaces are of a uniform height, as was in fact done in this case. The top batten, to which the printing paper is attached, should also be adjusted to the same thickness.

Working arrangements

If you are to work efficiently, you will need to give careful thought to your layout and arrangement within the working space available.

The corner of a living room could prove quite adequate, providing that it is properly organized and that you are not too ambitious about the size of your prints.

Working surfaces

Assuming that there is no spare room that can be used for the purpose, and that you are therefore confined to a part or corner of a room, your first requirement will be a good sturdy table or bench approximately 2×5 ft. Ideally there should be some natural light source, preferably to the left of or in front of the table or bench, so that you are able to judge colour values correctly. If this is not possible, find a source of natural light where you can mix and test your colours before printing. Artificial light will be perfectly suitable for the cutting and printing stages.

As your table or bench top will have to serve as both a cutting and a printing surface, it will be necessary to clean down the top

Fig 61 Sketch showing layout of corner of a room for printing

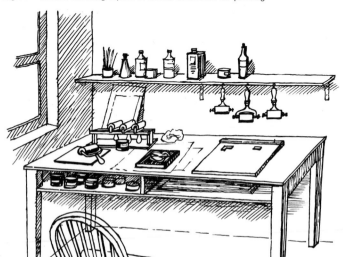

between the cutting and printing stages, removing any lino or wood chippings. These might otherwise get onto the inking slabs, or be picked up in other ways and transferred to the printing surface. Keep a small stiff brush for this purpose, and make sure too that your blocks are free of any loose chippings before inking them up. Newspaper or a plastic covering can be used to protect the table top, and replaced or cleaned down when necessary.

Fig. 61 shows a practical way of arranging your materials and equipment for printing: inks, inking slabs and rollers to the left, printing area in the centre, and printing paper on the right. If your working surface is not large enough to allow a space in the centre for the rolling-up and printing stages, a narrow shelf could be constructed beneath for the inks, papers, etc. An open shelf of this kind is likely to prove more useful than drawers.

Fig. 63B shows a simply-constructed stand in which the rollers can be placed when not in use. This is quite suitable for the cheaper rubber rollers; but for a gelatine or plastic roller (which, incidently, must never be left to rest on its face when not in use), I would suggest the use of a hook and rail, as shown in fig. 63C. Colours could be kept either on a shelf underneath your working surface, with the paper, or on shelves, as shown.

You may sometimes find it necessary to use the floor, if a block is too large to work with on the table; I have frequently had to do this myself.

A simple form of drying rack will need to be constructed and placed conveniently near the table. The peg type in fig. 63A is a very easy one to make, using $\frac{1}{2} \times 1$-in. battening and nailing the plastic or wooden clothes pegs approximately 6 ins apart.

General care of tools and equipment

Having completed your printing for the day, make sure that your tools and equipment are left in proper order.

Palette knives, inking slabs and rollers must never be left with colour on them. If oil-colour printing inks have been used, clean them thoroughly, using turpentine substitute or paraffin as a solvent. Dry them and return to their normal places. Water is the only solvent required for water-based inks.

Cutting tools should be placed in a roll-up bag, or in a suitable rack, to ensure that the cutting edges are not damaged, and all metal tools, including palette knives, should be smeared with a little thin oil if they are to be left for a period of some time without being used.

E

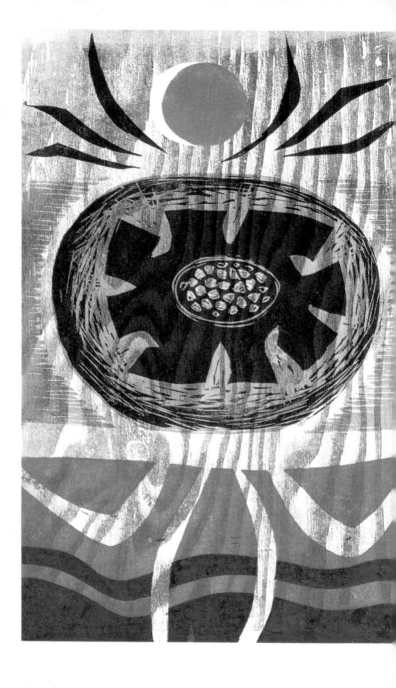

Fig 62 Print produced using combined block method–lino, hardboard and wood grain (see figs 55–60)

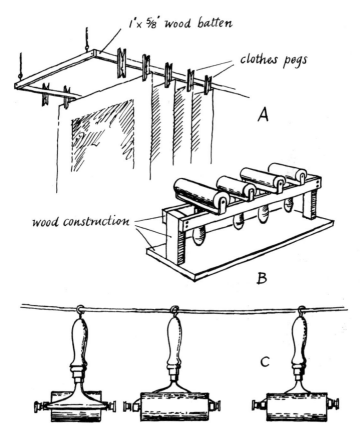

Fig 63 A–simply constructed print-drying rack; B–roller stand; C–gelatine and composition rollers must be hung up

One final point, colours must be properly sealed-off after use. This is especially important if they are contained in tins. If you put a piece of greaseproof paper over the surface of the colour before putting on the lid, this will help to prevent them forming a skin over the top.

Printing with a press

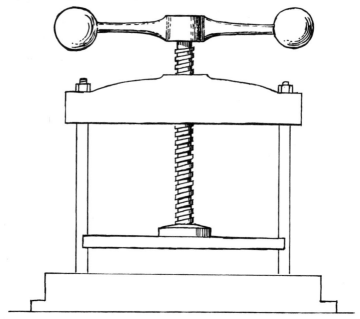

Fig 64 Document press

Although a press is by no means an essential piece of equipment (with few exceptions all the prints used to illustrate this book were printed by hand), there are occasions when access to a press would be helpful; for example when considerable pressure is required. The simple document or thumb-type press shown in fig. 64 will be found very serviceable for most purposes, although somewhat restricted in the size of print that it will take, 10×12 ins being about the maximum. Pressure is applied by lowering the top plate, by a worm-type screw thread. This is attached (as shown in fig. 64) to a heavily-weighted arm which moves the plate up or down according to the direction in which it is turned.

Packing the press

The main purpose of the packing is to ensure that every part of the raised surface of the block receives equal pressure, so that an even density of ink is taken up onto the printing surface of the paper. There are occasions, however, when the packing may also serve to control the density of colour in the various parts of a print.

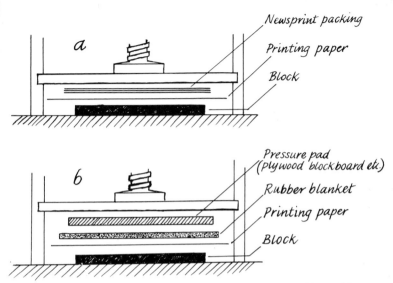

Fig 65 A – normal packing for relief block; B – packing required for picking up ink from more than one level

In cases where it is required to print from different levels of a block, as in collage prints, where the elements to be printed vary in height, a different form of packing will be necessary. Fig. 65A shows the type of packing that would normally be used when printing with a conventional block (wood, lino, hardboard etc.) in which the raised surface is of a uniform height and a print of even density is required.

The block (or plate) is placed down on the bed of the press, the printing paper placed over the top, and half a dozen clean sheets of newspaper, newsprint or similarly soft packing paper placed over the back of it (fig. 65A). In the case of thinner materials, such as lino and hardboard, it will be helpful either to glue them down first onto a heavier support – a piece of blockboard, plankwood or chipboard no thinner than $\frac{5}{8}$ in. (it may be thicker) – or to put them down onto a support of this kind, to facilitate proper control in the press.

Fig. 65B illustrates the form of packing used when printing from blocks which have been inked-up on different levels. This applies to collage blocks for instance, where the materials will differ in height – card, fabric, metal cut-outs etc. – or to printing from weathered plankwood which has been inked-up with a soft roller to pick up the lower levels between the hard grain. In place of the packing paper, a soft rubber or foam sponge blanket is used to press the paper down into the hollows of the block.

Printmaking for children

Although few children will have occasion to use print techniques in later life, I am convinced that there is no better way of helping towards an awareness and true understanding of design and its meaning than through the printed image. For this reason I would advocate that some form of printmaking should be part of the work of every art class, particularly those in which young children are involved.

The prints which I have chosen to use in this section are of an essentially experimental nature, offering a basis for individual experiment and project work.

The materials that have been used are of the cheapest and most easily-obtained kind. Most of those used for the collage prints were waste materials picked up from various sources.

The cardboard and paper block prints seem to me a very good way of introducing children to design and its application to pattern construction.

Collage prints on the other hand, in which elements quite different in shape and surface texture may be used individually, or brought together to form assemblages, offer a further means of heightening the student's sensibility to the quality and character of things in the visual world around him.

Fig 66 Cutting the cardboard shapes

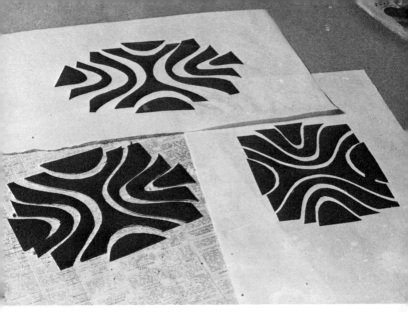

Fig 67 Prints taken from opened-up cardboard shapes

Cardboard and paper prints

The prints illustrating this section were produced using simple paper or cardboard blocks. Inexpensive materials of this kind can serve very effectively as a means of introducing students and children to printmaking, but perhaps even more especially as a means of helping to develop in them a sense of pattern and design.

Any type of cardboard or paper can be used for constructing relief blocks of this kind. Different surface textures can be exploited in interesting ways.

Although the number of prints which can be taken from blocks of this kind is limited, compared with more durable materials, the freedom allowed in the cutting and arranging of shapes more than compensates for this restriction.

Scissors and a sharp knife are the only tools required, and some rubber solution (cement) or similar fixative for attaching the cut shapes to a suitable base, when necessary.

The prints shown are of two kinds: 1 – card prints made with shapes cut out, inked-up, and arranged freely for printing; 2 – prints using mainly paper or thin card fixed down onto a similar base material before inking-up.

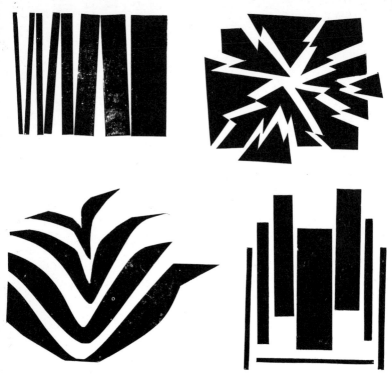

Fig 68 Cardboard shapes cut out and arranged in various ways to express movement of different kinds – compression, space, explosion, flight, etc.

EXPANDED CARDBOARD PRINTS

The thicker cardboards, or strawboard, will be found most suitable for this kind of print, in which the shapes are cut out with a knife as shown in fig. 66. Inking blocks of this kind will be found easier if the elements are kept together as a block and rolled-up in one operation, rather than separately. After inking-up the shapes can be opened out and arranged before taking a print, as seen in fig 67.

The value of this kind of experiment is obvious. No child using this simple method of printing, in which complete freedom of arrangement is possible, could help but become aware of the importance of both the positive and negative areas in pattern construction.

Using simple abstract shapes in this way, he will discover how different rhythms can be created by varying the disposition of the shapes.

Colour could be introduced in exercises of this kind to help develop and give further interest to the experiments.

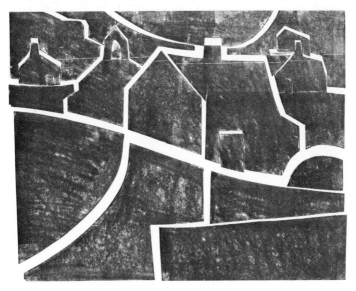

Fig 69 Expanded cardboard shapes used pictorially, as a means of experimenting with varying emphasis of line

Fig 70 Shapes removed, to develop pattern interest

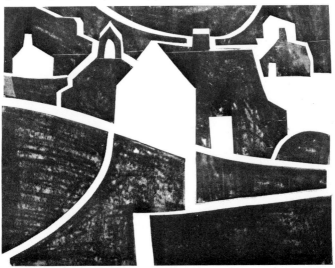

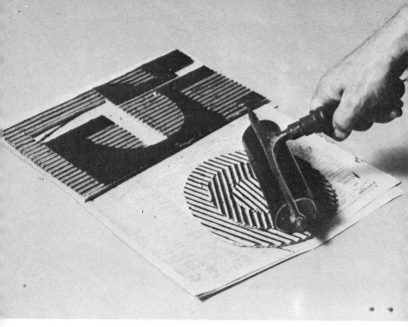

Fig 71 Corrugated cardboard blocks inked-up ready for printing

Cardboard and paper blocks absorb a certain amount of ink at first. However, once the ink has been allowed to dry, it will help to seal off the surface to give more solid prints.

Similar experiments to those I have described can be carried out using pictorial forms. The shapes are cut out in the same way and expanded, as shown in figs 69 and 70. The experiment has been extended here by the removal in fig. 70 of certain shapes, so introducing solid areas of white into the print, to give varying emphasis. Once again a further colour might have been used to develop the exercise.

CORRUGATED CARDBOARD PRINTS

For experimental printmaking this is one of the most useful kinds of waste material that I know of. Quite apart from the many interesting ways in which it can be cut up and arranged to form simple relief blocks (as shown in fig. 71), it can be employed quite widely in conjunction with other materials to create collage prints. Fig. 83 illustrates an example of this kind.

Most kinds of corrugated cardboard can be used. The type used for fig. 71 was a cardboard of the sandwich variety, the corrugated

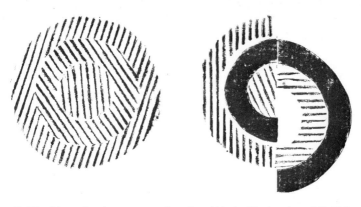

Fig 72 Prints taken from corrugated cardboard blocks. The two top prints were taken from sandwich-type cardboard, top layer peeled back, white areas cut away. Lower prints were taken from single face cardboard, rings cut through and rotated

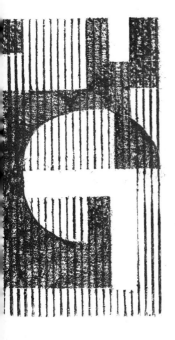 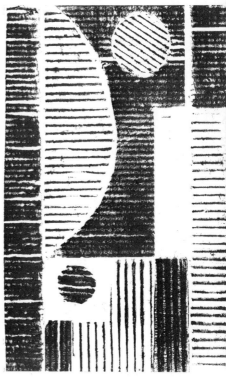

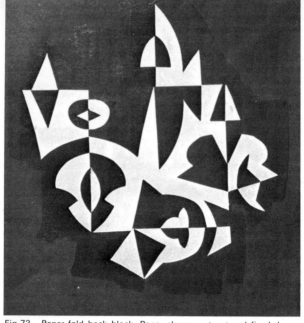

Fig 73 Paper fold-back block. Paper shapes cut out and fixed down onto grey sugar paper (a soft textured paper)

part faced on either side with thin cardboard. When using this type of cardboard the corrugations are opened up, by cutting round the shapes with a sharp knife and peeling off the top layer of facing. If white areas are required, the cardboard is cut right through and the shape removed. Fig. 72 (top) shows prints made from this sort of corrugated card. The lower prints were made from the sort of cardboard faced on one side only. In this case the cardboard is cut right through, so the direction of the lines can be varied by rotating the rings.

This technique of cutting out shapes and rotating or removing them can be exploited in a variety of ways. Shapes which have been cut out may be inked-up in a different colour and replaced in position, to produce a two-colour print (or more). If the shapes are symmetrical, either side could be inked-up, to produce either the corrugated line or a solid area of colour from the filled or back face of the cardboard.

Corrugated cardboard prints are best suited, as indeed are all cardboard and paper prints, to simple abstract treatment.

PAPER FOLD-BACK PRINTS

This is another way of experimenting in print form with expanded shapes, using paper as a block.

Unlike the earlier cardboard examples, the paper cut-out is fixed down on a sheet of thickish paper or thin cardboard before rolling-up, as shown in fig. 73.

The purpose of this kind of exercise is principally to demonstrate how a static rectangle of paper can be given exciting movement and pattern by simply extracting shapes out of it.

A print taken from a similar block (fig. 75) shows a white halo effect around the paper relief shapes, which have printed up fairly solidly in contrast to the textured or broken background colour. This has been effected by using a roughish textured paper as a base block, which, owing to the very shallow relief, has picked up a fair proportion of the ink in the rolling-up stage. All kinds of textured and embossed paper or cardboard may be used in this way to give surface interest to your print.

The shape you begin with need not be confined to a square, as in this case. It could be an irregular form, but generally speaking geometric shapes – square, circle etc. – will give the most satisfactory results.

Fig 74 Print being taken from paper fold-back block

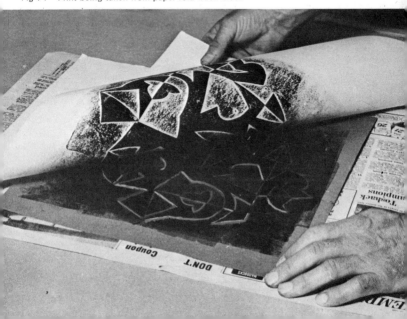

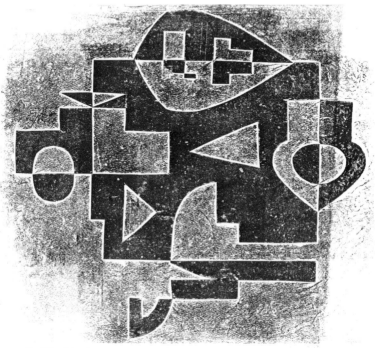

Fig 75 Print from fold-back block

Another form of fold-back print is shown in fig. 76. In this case the shapes have been created by cutting into a sheet of paper with a knife and folding the paper back onto itself. After cutting into the paper it is turned back within the rectangle to form the raised printing surface. Prints produced in this way will have areas of white in the open parts, black or fairly solid colour on the raised parts, with a delicate halo of white surrounding them, and tones varying between grey and black picked up on the slightly lower areas of the printing surface.

Like the expanded paper print, the fold-back shapes must be fixed down firmly before rolling-up, to prevent them being picked up by the roller. If white is to appear in the print within the open areas, the sheet should not be fixed down onto a base sheet, as

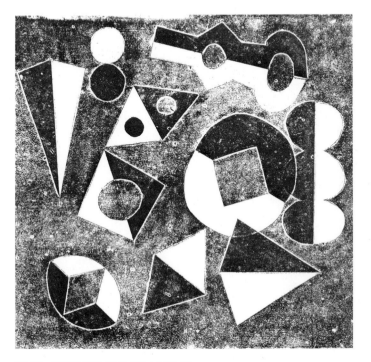

Fig 76 Overlapping paper fold-back print

in the previous case, but inked-up on a flat surface, removed, and placed on a clean sheet of newspaper before printing.

Repeat patterns

The examples on page 84 of repeat patterns were produced using simple cardboard blocks. These were built up from two pieces of card roughly 4 ins square. One piece was used as a base block, the other was cut up in various ways, parts selected and glued down onto the base block. The cardboard used for the base block can be quite thin. The one used for the relief shapes will require to be fairly thick (strawboard was used for the above examples) in order to facilitate inking-up.

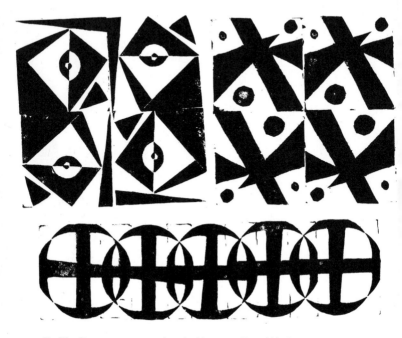

Fig 77 Repeat patterns produced with cut-cardboard blocks

Using this method of building up the relief, as opposed to the more orthodox one of cutting into the block, has obvious advantages, especially for the very young, who are likely to experience difficulties in handling the tools. Furthermore the student has greater freedom in the arrangement of the shapes before fixing them down onto the base block.

Patterns produced by this method, in which a sharp knife or scissors are used to cut out the relief shapes, will differ in character to some extent from those printed from cut blocks in which the V tool and gouges have been used to cut around the shapes. Fig. 78 shows examples of patterns produced from lino-cut blocks. When using the tools, textures can be developed more readily than with the card method. Also the shapes become more varied

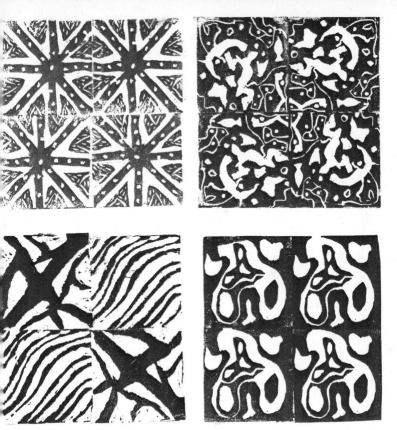

Fig 78 Repeat patterns (lino cuts)

and personal. Despite these considerations however, there is still a very strong argument for the use of the cardboard block I feel, both as a means of introducing the student to the principles of repeat pattern, and for the degree of freedom it allows in the arrangement of the cut elements. It helps to develop in the student a greater awareness of both the positive and negative areas of his design.

Very interesting results will be got by making up two blocks from the single piece of cut cardboard – positive and negative units – to act in a complementary way in pattern. By inking-up the blocks in different colours the experiments could be further extended.

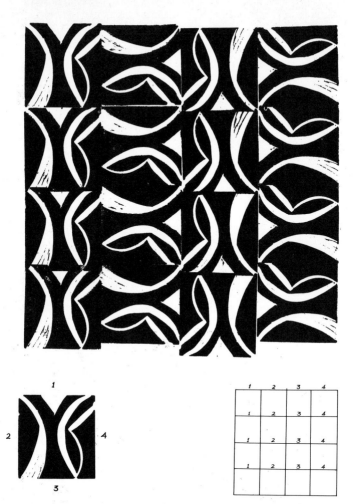

Fig 79 Pattern produced by rotating block (lino), as shown in diagram

One final word: in order to explore the potential of any simple pattern unit of this kind fully, the student must be encouraged to experiment as freely as possible with the arrangement of his block or blocks. By using different systems of rotating the block (as shown in fig. 79), exciting and unexpected rhythms will be discovered. The most elementary shape, experimented with in this manner, will be found most rewarding.

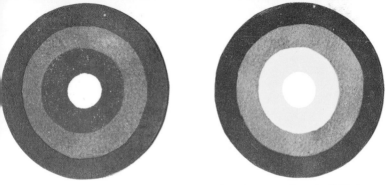

Fig 80 The two colour discs illustrate how the colour range in a single-block colour print is affected when the order of printing the colours is changed: A – yellow, blue, red; B – red, yellow, blue

Fig 81 Collage print

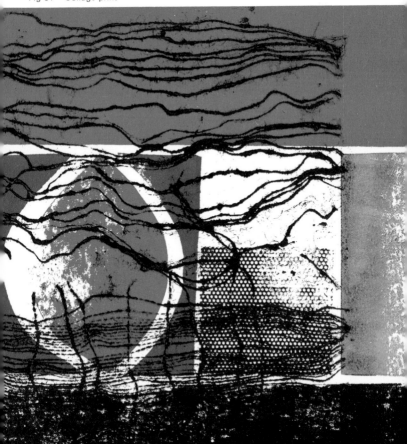

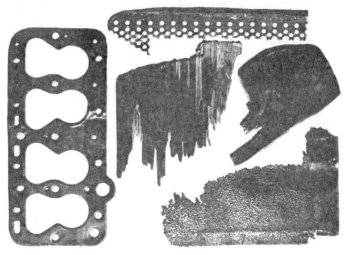

Fig 82 Collection of found objects suitable as relief blocks for collage printing

Collage prints

For those who are unfamiliar with the term Collage, it means simply a bringing together of elements extracted from various sources, to form a composition or composite design.

When used in print form, these elements will be principally chosen for their shape and textural interest.

In an earlier book in this series, *Simple Printmaking*, I dealt with the subject of collage, and of the various ways in which it could be used in print form.

Collage, apart from its use as a serious art form, offers extremely exciting possibilities for experimenting in a variety of ways with found objects–with their shapes and surface qualities. Inked-up, even the most familiar material may reveal quite unexpected textural interest. By combining these differences of shape and texture to be found in the everyday things around us, new experiences can be expressed.

Materials

There is virtually no limitation to the materials that may be used in collage prints. Any surface in fact that can be inked-up with a roller, and which is sufficiently firm to take an impression from, can be exploited in some way.

Natural forms–leaves, feathers, dried flower heads, tree bark, wood grains, slate, stone, etc.–offer a wide field in which to explore the pattern and rhythms in natural growth structures. In

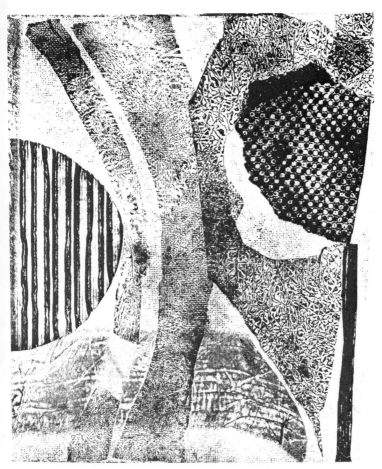

Fig 83 Corrugated cardboard, crumpled paper and embossed paper shapes, cut out, and fixed down onto hardboard base block. The whole inked-up and printed

man-made forms the range of materials which are of potential value in printmaking is pretty well inexhaustible–papers of every description, fabrics, metal and plastic forms, glass and various kinds of fabricated construction board, quite a few of which I have referred to earlier in connection with block cutting: hardboard, chipboard, softwood, etc.

In *Simple Printmaking* I dealt principally with ways in which collage might be used pictorially in printmaking. My reasons for introducing it here are primarily to illustrate ways in which it can

Fig. 84 Heavy canvas material, wool and crumpled foil disc, fixed down onto base block, inked-up and printed

Fig 85 Further example of fixed method, in which paper, fine muslin, lace, raffia matting, coarse hessian (burlap) and cotton were used

Fig 86 Prints taken from various elements cut out and brought together as an assemblage. Feathers and leaves were offset onto paper using a soft roller

be of value in helping to develop a greater awareness in children of the particular pattern and textural qualities inherent in the things. By encouraging them to bring into the class materials which have interested them for their shape or surface textures, they are more likely to participate with enthusiasm in the experiments.

I must point out that when using collage materials there is no fixed method of working–in many cases one is obliged to improvize in order to achieve the result required. There are however two methods which will generally be found to cover most eventualities.

Fixed method, using base block

This is the method mainly employed when dealing with either a fixed arrangement of elements which are to be printed together, examples of which are shown in the accompanying illustrations, or in such cases where the material or materials are of too flimsy or flexible a nature to print from without first fixing them down onto a suitable base block–e.g. fabrics, thin tissue papers, string, cotton, etc. As a method of working it is especially suitable for exercises in which a number of different materials, which may be

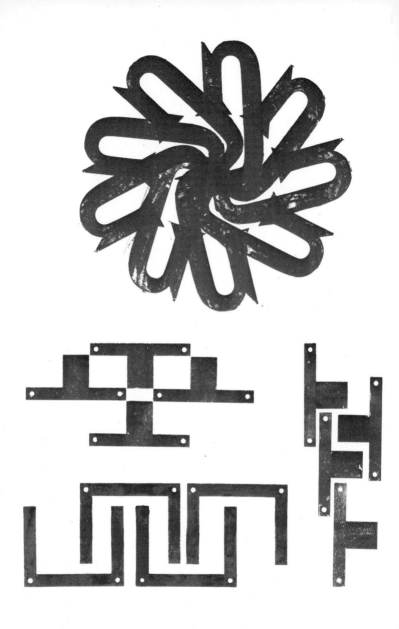

Fig 87 Top, wood block letter form used to produce pattern unit. Bottom, patterns constructed with plates taken from old wireless transformer

Fig 88 An interesting image produced by inking-up thin rubber blanked strip, once only, and rotating it to give graduated tone

pre-cut shapes, or elements of natural form – leaves, wood grain etc. – or again shapes cut out from other man-made materials – fabric, paper, card, etc. – are brought together to form an assemblage from which to print.

The principal limitations of this method have to do with colour and the thickness of the materials used. Unless the various elements fixed down are sufficiently isolated, it will be found difficult, if not impossible, to ink them up in separate colours. Furthermore, unless the materials used are of a reasonably uniform height, difficulty will be experienced both in the inking-up and printing stages. For these reasons it is a method best suited to black or single-colour prints, as shown in figs 83–85, which are simple experiments in combining textures extracted from a number of selected materials. It can however be used very effectively in conjunction with the second method, which I have called the 'direct method'.

Fig 89 Free method – various elements inked-up in black or colour, and placed down separately to print one over another to form a balanced arrangement

Fig 90 Similar experiment as above

Fig 91 Piece of drift plywood, eroded by the action of water, and revealing grain structure at different levels

Fig 92 Print taken from above block using a soft roller. A ball of rag was used as a burnisher to press paper down onto the various levels

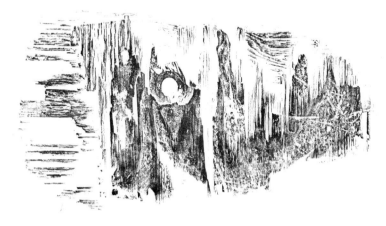

The direct method

This offers considerably greater freedom in the arranging and printing of collage materials, providing the materials used are of a sufficiently rigid nature–e.g. wood, metal, plastic, cardboard, glass, etc.

Unlike the Fixed Method the various elements are not attached to a base block, but inked-up individually and either positioned on a base block, as shown in fig. 59, or placed down directly onto the printing surface.

Figs 87–88 show examples in which single elements have been printed to form simple pattern units. The shapes were inked-up in black or colour and placed down onto the paper. A hard roller was used to burnish over the back of the raised metal or wood shapes, in order to force the colour onto the printing surface. Apart from the greater flexibility of arrangement offered by this method, it has the additional advantage of allowing the different elements to be inked-up in any colour and printed one over another, in whatever order one wishes, so making it possible to develop the special effects of colour within a design. Furthermore, differences in the thickness of the materials present no problem when printed separately in this way.

In cases where the materials to be used are a combination of both rigid and flexible forms, it will be necessary to use both methods in order to achieve the most satisfactory results. The prints shown in figs 81, 89 and 90 are examples illustrating the use of combined methods.

Owing to the absorbent nature of certain materials, e.g. fabrics, paper, cardboard, etc., difficulty may be experienced in achieving a sufficiently strong image. This will largely be overcome by allowing the ink to dry into the surface to act as a seal before inking-up for printing.

Alternatively a fairly heavy coating of size may be used.

Tools

For the purpose of cutting and shaping the various materials used in collage printing a few simple tools will be required:

Tenon saw. This will be found quite adequate for dealing with most types of sheet material.

Ripsaw. For thicker materials such as plankwood, chipboard and blockboard, this will be necessary

Tin Snips. These will serve extremely well for shaping all forms of thin metal sheeting, chicken wire, etc.

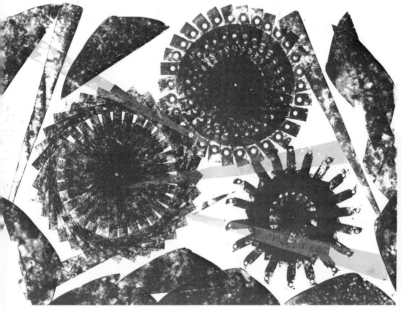

Fig 93 Free Method used. Lino and metal transformer plates, inked-up in black and colour to form an exciting image

Scissors. For most of the thinner cardboards, and for papers of every description, a pair of scissors will be all that is required. These will also be found extremely useful when dealing with fabrics of various kinds.

With the addition of a good sharp penknife, or better still a Stanley knife, for cutting the thicker types of cardboard, these are the only essential tools that you are likely to need.

Offset printing

This is an interesting and useful addition to the conventional method of printing from relief surfaces.

In offset printing the required image is transferred from the inked-up surface onto a roller, which is then used to transfer it onto the printing surface (see figs 94–96).

Although its uses, as far as the printmaker is concerned, are rather limited, it is possible with this method to achieve certain effects which cannot be got by other means.

The roller used for this purpose is made of gelatine or a special soft plastic, both of which possess two important qualities – a fine, even surface and pliability.

Using this type of roller it is possible, because of its relative softness, to ink-up different levels of a relief surface. For example, if a piece of plywood, from which part of the top veneer had been stripped, was inked-up with a roller of this nature, parts of the lower level of the surface, dependent on how much pressure was

Fig 94 Inking-up surface with hard rubber roller

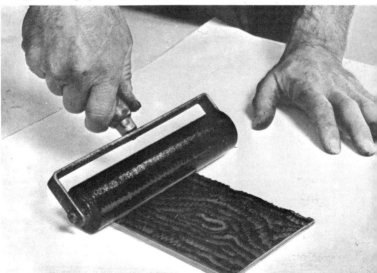

applied, would receive the ink as well as the top surface. This inked image could now, using a clean roller of a similar kind be transferred back onto the printing surface.

One of the limitations of this method is the fact that the size or area of the image that you wish to offset must not be larger than either the width or circumference of the offset roller, and these are rarely more than 10 ins wide by $2\frac{1}{2}$ ins in diameter. They are also expensive.

A particularly useful way of employing offset is in pattern and textural experiments, using found objects, cut blocks, or any surface textures which can be inked up.

One final point to remember is that gelatine rollers must not be used with water-based inks, as these have a chemical effect on the gelatine, causing it to perish.

This method has particular advantages when taking impressions from very delicate elements, such as leaves, feathers and similar

Fig 95 Transferring image onto soft gelatine roller

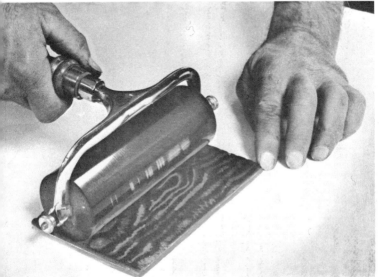

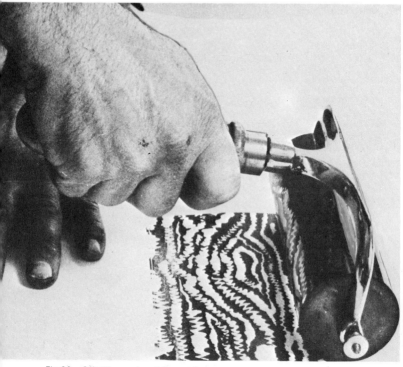

Fig 96 Offsetting onto printing surface

forms. The examples of leaf and feather prints in fig. 86 were
produced by this method.

The accompanying illustrations, figs 94–96, show a texture
cut in lino being transferred onto paper using a soft gelatine roller.
As only a print from the top surface was required, a hard rubber
roller was used to roll-up the ink on the block.

List of suppliers

Wood offcuts, any timber merchant (lumberyard)

Prepared blocks, T. N. Lawrence & Sons, 2 Bleeding Heart Yard, Grenville Street, London EC1

Hardboard, softboard, chipboard etc., any timber merchant (lumberyard)

Lino offcuts, any large furnishing store

Block printing inks (oil and watercolour) and colour reducer (oil only), T. N. Lawrence & Sons

Letterpress inks and colour reducer, Gilbeys and Sons Ltd, Reliance Works, Devonshire Road, Colliers Wood, London SW19
Winstones Ltd, 150 Clerkenwell Road, London EC1

Solvent, for thinning oil colours and cleaning up, white spirit (mineral spirits), any paint or hardware store

Cutting tools, T. N. Lawrence & Sons

Rollers, palette knives, inking slabs, Dryad Handicrafts, Northgates, Leicester

Sharpening stones, Any good tools store

Papers—for printing, for rough prints and general use. Cartridge (drawing) papers, sugar paper, tone and coloured papers, poster papers, newsprint etc.,
Winsor & Newton, 51 Rathbone Place, London W1
F. G. Kettle, 127 High Holborn, London W1

Special printing papers for artists' proofs, Whatman (Waterleaf) paper, Barcham Green (Waterleaf) paper, wide range of plain and textured Japanese papers, T. N. Lawrence & Sons

List of suppliers (USA)

In the United States, all of the material above may be purchased at a local lumberyard or at the art materials supply store nearest you. For mail order purchases, send for a catalogue from:

Arthur Brown & Bro.
2 West 46 Street
New York, New York

Leisure Crafts
941 East Second Street
Los Angeles, Calif. 90012

For further reading

Linocuts and wood cuts by Michael Rothenstein; Studio Vista, London and Watson-Guptill, New York

Engraving on wood by J. Farleigh; Dryad, London

Making colour prints by J. Newick; Dryad, London

Creative printmaking by Peter Green; Batsford, London; published by Watson-Guptill, New York as *New creative printmaking*

Printmaking by Gabor Peterdi; Macmillan Co., New York 1959

Printmaking today by Jules Heller; Pitman, London 1958

Printmaking without a press by Doub Erickson; Adelard Sprout

Craft of Woodcut by J. R. Biggs

Frontiers of printmaking by Michael Rothenstein; Studio Vista, London 1958

The Floating World by James Michener, Random House, New York and Secker & Warburg, London 1954

Relief printmaking by Michael Rothenstein, Studio Vista, London and Watson-Guptill, New York

Index

Acknowledgments
I should like to express my sincere thanks to my wife Pat for her help and encouragement with the text and illustrations; also to Mr H. H. Shelton, ARCA ARE FSAE ASIA (Ed) NRD, Principal of Hornsey College of Art, for his kind permission to use prints made by students of the Foundation Studies Department; and to Mr L. Lavington for his very generous help with the photographs.